NEW JERSEY WOMEN

A History of Their Status, Roles, and Images

by CARMELA ASCOLESE KARNOUTSOS

D1591273

TRENTON
NEW JERSEY HISTORICAL COMMISSION, DEPARTMENT OF STATE

Copyright© 1997 by the New Jersey Historical Commission
Department of State
All rights reserved
Printed in the United States of America

New Jersey Historical Commission, Department of State
CN 305
Trenton, NJ 08625

Designed by Nancy H. Dallaire and Lee R. Parks
Cover designed by Nancy H. Dallaire

Library of Congress Cataloging-in-Publication Data

Karnoutsos, Carmela Ascolese, 1942-
 New Jersey women: a history of their status, roles, and images/by Carmela
Ascolese Karnoutsos.
 p. cm.—(New Jersey history series; 9)
 Includes bibliographical references.
 ISBN 0-89743-086-7
 1. Women—New Jersey—History. I. New Jersey Historical Commission.
II. Title. III. Series.
HQ1438.N5K37 1997
305.4'09749—dc21

 97-24147
 CIP

TABLE OF CONTENTS

For Rose Rinaldi Ascolese

INTRODUCTION

Women in New Jersey have devoted considerable effort to improving their lot in society. Most probably have not viewed their efforts in such grand terms as working towards full and equal participation in society. Indeed, an eighteenth-century New Jersey woman would have found this phrase meaningless. But, as they worked to secure their rights to own property, to divorce, and to vote, and as they opened schools or marched for the Equal Rights Amendment, their individual struggles have increased the opportunities for all.

Most seventeenth- and eighteenth-century New Jersey women worked at home. They ran their households, cared for their children, and clothed and fed their families. If they lived on farms they also helped their husbands in the fields. Women were subservient to men by law and tradition; they had limited property rights, divorce was difficult, and generally they could not vote. Their role was private rather than public. Women without husbands, whether spinsters or widows, had an uncertain social role and often faced extreme poverty.

As New Jersey's economy changed from agricultural to industrial, women began to find employment in the new industries (mostly in mills) outside the home. Millworkers, whether male or female, were ill paid, but women earned less than men. They were restricted to jobs requiring fewer skills; men occupied all the skilled positions. Even those women who began to enter what we would now call the white-collar professions, such as teaching, were paid less than men.

Nonetheless, throughout the nineteenth century more women entered the public arena, either through employment or through a variety of reform activities—antislavery, prohibition, child welfare, and woman suffrage. Suffrage became the focus for many women interested in a vast number of other causes.

Once the suffrage battle was won in 1920, there was no single women's cause. Feminists campaigned for equal rights while social reformers worked to improve housing and child welfare. Still other women, appalled by the devastation of World War I, focused on peace activities. Professional women—a small group in that era—concentrated on establishing themselves in male-dominated fields.

Many women found jobs as the postwar economy boomed, but when the national economy collapsed in the 1930s tens of thousands of New Jerseyans lost their jobs, and women found it difficult to get work or keep it; they were urged not to "steal a job from a man." The employment picture did not improve until World War II. Then many new jobs were created to produce tanks, airplanes, and other armaments, and many old jobs were vacated by men joining the military. Thousands of women flocked to New Jersey factories.

Most contemporary New Jersey women do not confine their activities to home and family as women once did. They still run households, but they also invest energy in jobs and in many other activities, from party politics to social reform to ecology. Some, like Alice Paul and Mary Philbrook, have been in the forefront of the struggle for social reform and women's rights.

The history of women in New Jersey can tell us a great deal about the story of women in the United States. This short book can give no more than an overview, but I hope the overview will challenge as well as inform.

Acknowledgements: My appreciation for assistance in preparation of this manuscript is extended to The New Jersey Historical Society, the Jersey City Public Library (New Jersey Room), and the Jersey City State College Library staff. I also express sincere gratitude to Dr. Stanley N. Worton, Dr. George Karnoutsos, Michael J. Ascolese, Dr. Barbara Petrick, and to Historical Commission staff members Mary R. Murrin, Lee R. Parks, and Richard Waldron for their comments and editorial advice on the manuscript, for the contents of which I take full responsibility, and to Commission staff member Nancy H. Dallaire for the design of the book.

CHAPTER ONE

Settlers and Founders

The women of colonial New Jersey came from a varied European heritage. By the early eighteenth century, representatives of several ethnic groups—Dutch, Scots, Scots-Irish, Germans, Swedes, Finns, and English—had settled in New Jersey. They brought with them many different religions—Presbyterian or Congregational, Dutch Reformed, Quaker, Lutheran, Baptist, Mennonite, and Anglican. New Jersey's economy was largely agricultural. Farm life—the endless cycle of plowing, planting, and harvesting—dominated the lives of 90 percent of the colony's inhabitants, both women and men. The remainder of the male population labored in a few industries such as iron manufacture, shipbuilding and whaling, as small tradesmen, and in occupations such as blacksmithing and inn-keeping.

Home and Hearth

Colonial women lived and worked in a preindustrial society that was labor-scarce, had few consumer goods, and assumed a division of labor according to sex. While men worked in the fields or at various trades, women of all classes were responsible for household management, a duty which included food production and clothing manufacture. Homemaking and child care dominated their lives.

Family income and social status determined the lifestyle, dress, and the kind of work women performed in the home.

Most women worked within a household setting, as worker-companions with their husbands. Women who worked generally fell into one of two groups. Either they were widows or single women who had to find work to support themselves or they worked with their husbands in occupations such as storekeeping.

Wives of important or prosperous men (large landowners, the few merchants, important government officials) attended to their husbands' estates as hostesses and conducted the social functions appropriate to their husbands' stations. They handled the fine details of entertaining, which meant arranging parties and dances or preparing for weekend or long-term guests. They also supervised slaves and indentured servants who assisted in household chores. The well-to-do were not the only ones who entertained. Esther Edwards Burr of Newark recorded a busy round of activities in a diary covering the years 1754 to 1757. As the wife of the important Presbyterian minister Aaron Burr (later the second president of the College of New Jersey, now Princeton University), Esther Burr's duties went beyond homemaking. She was also expected to serve as hostess to members of her husband's congregation, visiting ministers, important townspeople, and even college students.

New Jersey's population was not, of course, wholly white. Unfortunately we do not know a lot about the lives of black women, even less about the lives of Native American women of that period. There were many African-Americans in New Jersey, most of them slaves. We do not know for certain when blacks first appeared in New Jersey, but the Dutch began to import slaves in large numbers in the mid-seventeenth century. The black population grew rapidly throughout the eighteenth century, both by natural increase and by importation. By 1790 there were about fourteen thousand blacks in New Jersey, nearly 8 percent of the population.[1] Many of the men worked on farms; others toiled in mines, shipyards, lumberyards, or as domestics. A few were skilled craftsmen. The majority of slave women worked as domestic servants or as farmhands in addition to their own family responsibilities. Black women seem to have had a somewhat lower fertility rate than white women, particularly in the early years of the century. Census figures record an average of just over two children per adult white woman and just under two children per adult black woman. The figures show that the black population both had a lower fertility rate and was slightly

older; the two things would tend to be self-reinforcing.[2]

White female indentured servants also came to the colony, usually alone. American colonists paid for their transportation, food, and clothing, and they worked several years to compensate them. The average length of service was four years, during which time female servants hoped to meet men whom they could marry to establish independent households. After the expiration of their first contracts, servants wishing to remain in their masters' service could enter into new contracts. Unlike slavery, indentured servitude was temporary service and a means for poor free subjects to come to the New World. The practice was not without its abuses and hardships, but it was not bondage and it was the way many women and men emigrated.

Most white New Jersey homemakers maintained self-sufficient households with the assistance of daughters and perhaps unmarried female relatives. Wives frequently worked as partners with their husbands, learning their husbands' occupations in various trades and shops, and even toiling as field hands during planting and harvesting seasons. A number of women, like Catharine Anderson of Rahway, managed inns and taverns with their husbands, supervising the cleaning and meals much as they did in their own homes.

Meal preparation by women involved drawing water, butchering small animals, preserving meats, cooking, and tending the fireplace. Other domestic chores included growing herbs and vegetables, milking cows, making candles, soap, butter, and cheese, preserving and drying fruits and vegetables for winter, and plucking goose feathers for down mattresses.

Laundry was done much less often than it is today—perhaps once a month. Clothes were washed on the bank of a creek or stream or in large oak or maple tubs in which rainwater had been collected. After the clothes were scrubbed, they were dried in the sun on the grass or bushes. Before the introduction of the flatiron, a smoothing board was used to press clothes.

Making clothes for the entire family was an even more time-consuming and exhausting obligation for the colonial housewife. She spun wool or flax into yarn or thread, carded the yarn, wove the material, cut it and stitched it into garments.

Spinning was more than a woman's occupation, it was her preoccupation. Enough yarn had to be spun to make clothing for every family member and the task was a sign of women's

domesticity and femininity. Young girls and unmarried women or "spinsters" were also given the task. After the yarn was spun, it was bleached and dyed. Sometimes traveling male weavers would weave the yarn, as looms were too expensive for some families. Women also knitted stockings and mittens and made blankets and quilts. They often performed these essential chores while sharing the companionship of others and exchanging local news.

A young woman's education emphasized domestic skills. Her mother taught her all the things necessary for the smooth running of a household—spinning, weaving, sewing, and cooking. Some boys and girls attended dame schools, which were run in the homes by housewives with some education. There children were taught reading, writing, domestic skills, and perhaps religion.

The ethnic and religious diversity of the colony affected the development of a common or public school system. New Jersey allowed local townships to set aside land for grammar schools and nonsectarian academies. By the 1730s, groups of Calvinists, Anglicans, and Quakers had all opened schools in the colony. There were private theological schools, academies, and church schools, as well as free schools for poor children. The number of sectarian and other private schools delayed the development of the common school during the colonial era and had long-range effects on public education in New Jersey.

Housewives had complete responsibility for the health of their families. Their domestic treatment of common ailments was a combination of folk medicine and remedies learned from the Indians. Many women kept herb gardens from which their medicines could be made. They referred to newspaper and almanac reports of health cures and copied them into family receipt ("recipe") books. Because there were few trained physicians, women provided most of the medical care in their communities. They were unlicensed physicians, nurses, and midwives. Martha Austin Reeves of Cumberland County attended over a thousand childbirths, which she recorded during a forty-year career. Midwife Margaret Vliet Warne, known as "Aunt Peggy," served as a nurse, traveling throughout Sussex and Hunterdon counties during the Revolutionary era.

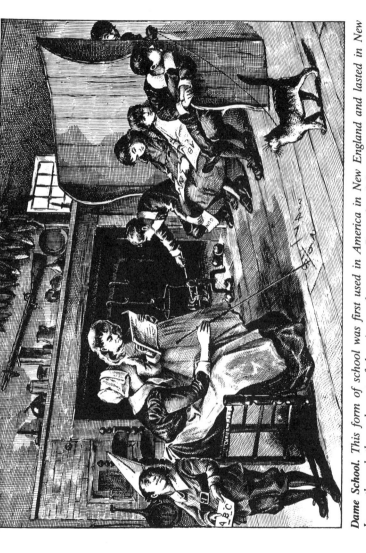

Dame School. This form of school was first used in America in New England and lasted in New Jersey through the early part of the nineteenth century. Reproduced from David Murray, History of Education in New Jersey, reprint of 1899 edition, Port Washington, NY, 1972.

Legal and Political Rights

Marriage alone provided social status for women. An unmarried woman of twenty-five had already missed her best chance of marriage. The general division of women, therefore, was between those who had husbands and those who did not. According to English common law, married women were regarded as "helpmates" or as being "one with their husbands." Sir William Blackstone, the English legal writer widely read in the American colonies, observed,

> the husband and the wife are one person ... that is, the very being or legal existence of the woman is suspended during the marriage, or at least is incorporated ... into that of her husband.... For this reason, a man cannot grant anything to his wife, or to enter into covenant [contract] with her; for the grant would be to suppose her separate existence; and to covenant with her, would be only to covenant with himself.[3]

Married women could not vote, sue or be sued, draft wills, make contracts, or buy and sell property. Upon marriage, wives forfeited all property, personal or real, to their husbands to own and control. Because they had limited legal rights, married women were reduced to a position of social dependency and legal inferiority. Married women were both protected and represented legally and politically by their husbands. Women's names were ignored and represented by the Latin word *uxor* (wife) on genealogy records, family records, business partnerships, deeds and mortgages, and tax schedules.

If women earned wages, the money legally belonged to their husbands. Fathers had custody of all children. However, the consent of a wife was needed in the sale of property and in "putting out" or apprenticing children, because of the potential impact on her future inheritance (dower right) of real estate.

Under English common law, whether her husband made a will or not, a widow had the right to one-third of her husband's real property. (The remaining two-thirds was divided among the children.) This right was called dower.

Dower represented only a life interest in the property. The widow had the right to the rents or any profits from it, but she could not sell the property or leave it to anyone else. If the couple had no children, the widow could claim half. Dower

represented the widow's minimum right. Her husband could leave her more than the "widow's third." He could not leave her less. If he attempted to ignore her dower rights, she could reject the will and demand the assignment of her thirds. However, if she did so, she lost any claim to the personal estate (movable property other than her own clothing, jewelry, and personal items) because dower, in both England and the colonies, did not include personal estate. All of the colonies followed the basic form of the English common law on inheritance.

Marriage settlements or prenuptial agreements might be arranged outside the common law system, allowing married women to own property independently from their husbands. When widow Elizabeth Smith Lawrence married Philip Carteret, the first English governor of New Jersey, she entered into a prenuptial contract with him to protect the inheritance of the seven children from her previous marriage.

For most men and women of colonial New Jersey, marriage was a civil institution. To those of the Calvinist tradition (Scots Presbyterians and New England Puritans or Congregationalists) or the Quaker tradition, marriage, albeit a holy union sanctioned by God, was a secular agreement with the exchange of vows by the couple. Marriages took place in the home of the bride and in the presence of a minister. However, the marriage license and the publication of banns (a check on a possible previous marriage of either party) were required by civil authorities.

Morals offenses, such as adultery and fornication, led to civil penalties. In New Jersey, as in most places in the seventeenth century, adultery meant sexual intercourse between any man and a married woman not his wife; fornication was sexual intercourse between any man and a single woman. The marital state of the woman, not the man, determined the nature of the offense. Obviously the woman's responsibility for the maintenance of the family unit was the greater. Few people questioned the state's right to regulate sexuality.

Morality was closely and harshly regulated. Fines and/or whipping were the usual penalties for both fornication and adultery. West Jersey laws, reflecting the gentler Quaker character of the province, were generally less harsh than those of East Jersey, but neither province treated morals offenses lightly, particularly

adultery. Adultery was an attack on family order and provincial Americans believed quite strongly that social order depended upon stable families.

During both the proprietary (1665–1702) and royal (1702–1776) eras, New Jersey had no legal provisions for divorce. Moral misconduct or abandonment might result in a divorce granted by legislative act. Divorce was by private legislative bill until 1844 when New Jersey ratified its second state constitution.

Under English common law, widows, single women, and wives with traveling husbands could work outside the home in order to support themselves. As independent women or *femes sole,* they could continue their husbands' businesses or official positions with almost as much economic authority. This included the right to own property, buy and sell land, sue and be sued, enter into contracts, and have the power of attorney. Widow Elizabeth Ray Clark (later Bodly), for example, continued to operate her husband's estate of 213 acres, which later became the commercial center of Port Elizabeth. As property holders and taxpayers, single women may have been technically eligible to vote. Those entitled to land ownership were defined as "all persons" who would swear allegiance to the King of England.[4]

Early governmental compacts gave women landholding privileges if for no other reason than to attract settlers. "The Concessions and Agreements of the Lords Proprietors" (1664) used the terms "person" or "persons," and "hee (sic) or she" rather than "men" and "women" to explain their rights and entitlements. Men and women alike received land incentives for recruiting servants to the colony. Other phrases in the Concessions such as "with an intention to plant"[5] seemed to indicate the proprietors' belief that female settlement encouraged successful, stable colony building. Throughout the colonial period land ownership was never defined as an exclusively male right. The terms "freeman" and "freewoman" were both used to describe landholders.

The right to choose the governor of the colony was reserved to the proprietors, and women could be proprietors. In West Jersey, Proprietor Elizabeth Miller, living in England, signed the "Surrender of the Proprietors" to Queen Anne when New Jersey became a royal colony. For a brief time, Lady Elizabeth Carteret, widow of Sir George Carteret, served as the sole

proprietor of the division of East Jersey. When her husband
died in 1680, Lady Carteret attended to the affairs of the colony
from England, corresponding with Governor Philip Carteret in
New Jersey. Along with the trustees of the Carteret estate, Lady
Carteret signed the document which led to the sale of the
province of East Jersey to William Penn and other Quaker
proprietors in 1683. East and West Jersey were reunited as a
royal colony in 1702 by Queen Anne.

Quaker Women

The Quakers (members of the Society of Friends) came to
colonial New Jersey in the late 1670s and 1680s in search of
a refuge from the religious persecution they suffered both in
England and in other American colonies. Most settled in West
Jersey, bought land, started families, and began to build com-
munities along the lines of their religious and social beliefs.

The Quaker belief in the primacy of individual conscience
presumed the spiritual equality of men and women, and Quaker
women enjoyed more equitable treatment within their religion
than Puritan women. Quaker women were permitted to become
ministers and participate in the governance of their religion.
According to Quaker founder George Fox, women as well as
men received the Inner Light (the presence of God to guide
the soul) at Quaker meetings and therefore could preach. Han-
nah Dent Cooper, for example, joined the Haddonfield Meeting
in 1736 and went to Barbados in the West Indies three years
later to perform pastoral services. As ministers certified by their
meetings, Quaker women traveled on horseback to preach at
various meeting houses and to care for the sick. In Burlington
County, the center of Quakerism in New Jersey, there were
reportedly twenty-five Quaker female ministers in 1767 on the
"list of ministers and Elders of Burlington Quarterly Meeting."[6]

Quaker women also participated through a series of women's
meetings which were parallel to those of Quaker men. The
activities of the women's meetings dealt with issues such as
marriage and family, household management, parenting, the
education of boys and girls, assistance for widows and orphans,
collection of funds for the poor, and discussion of community
problems. Quaker women were as outspoken as Quaker men
on social issues such as war, the abolition of slavery, and the

treatment of Indians. Some historians have held that it was the Quakers, through their belief in the equality of souls, who established a tradition of social activism for women in New Jersey.

One Quaker woman deserving special recognition is Elizabeth Haddon. In August 1701, at age nineteen, she left London to develop her father's 500 acres in New Jersey. With the assistance of neighbors and friends, she carved out a homestead which eventually became a successful farm. Afraid of the Indians when she first arrived in the colony, Haddon eventually taught them the Quaker faith. From them she learned the medicinal use of roots, berries, and herbs to help the sick. She married John Estaugh, a Quaker missionary from London. A devout Quaker all her life, she served as clerk of her local women's meeting for fifty years. She died at age eighty-two and was honored as "founder and proprietor" of the town of Haddonfield.[7]

Home Front and Battle Front

By the time hostilities broke out between the colonies and Great Britain in the 1770s, women made up one-half of the population of New Jersey. The American Revolution forced residents, male and female, to take sides. Those in favor of independence were known as patriots or Whigs, and those who opposed it as loyalists or Tories. Many New Jerseyans, both women and men, were indifferent to the war or were pacifists because of their Quaker faith. Some of the Quakers, however, permitted supplies to be taken from their houses, sheltered soldiers, and even attended the sick and wounded.

One such pacifist was Ann Whitall, a devout Quaker living in Red Bank, Gloucester County, near Fort Mercer. On October 22, 1777, when American, British, and Hessian forces clashed in the battle of Red Bank, a British cannon ball went through the side of the house while Whitall sat spinning in her home. According to legend, she picked up her spinning wheel and retreated to the cellar until the battle was over. She then nursed the Hessian soldiers in her home and reprimanded them for their brutality.

Another Quaker, Margaret Hill Morris, came to the aid of a local Tory. When American troops were searching for

Jonathan Odell, the Tory rector of St. Mary's Episcopal church, Morris hid him in her home.

> At last I open(e)d it (the door), & half a dozen Men all Arm(e)d demanded the keys of the empty House. I asked what they wanted there. They said to Search for a D—d tory who had been spy(in)g at them from the Mill. The Name of a Tory so near my *own door* seriously alarm(e)d me—for a poor *refugee* dignify(e)d by that Name, had claimed(e)d the shelter of my Roof & was at that very time conceal(e)d, like a thief in an Auger hole. I rung the bell violently, the Signal agreed on, if they come to Search, & when I thought he had crept into the hole I put on a very simple look & cry(e)d out, bless me I hope you are not Hessians.[8]

Women on both sides dreaded the war's effects on their lives. It meant the absence of sons and husbands, the death of loved ones, poverty from economic disruption of farms and businesses, and harsh treatment by soldiers. Annis Boudinot Stockton, who fled Morven, her estate near Princeton, when the British marched through New Jersey in 1776, returned to find her home ransacked. General Lord Cornwallis had used the mansion as his temporary headquarters. The British soldiers scattered the estate's horses and livestock, used the furniture for firewood, drank the wine, and burned papers and books.

Jane McCrea, a minister's daughter from Bedminster Township (Somerset County), was shot and scalped in 1777 by pro-British Indians while visiting David Jones, her fiance and a loyalist officer, near Fort Edwards, New York. On June 6, 1780, Hannah Odgen Caldwell was shot and killed by a British officer who fired through the window of her home in Connecticut Farms (now Union). Her husband, the Reverend James Caldwell, Presbyterian minister and chaplain with the New Jersey troops, claimed Hannah's death was revenge for his military activism. The deaths of these women provided ample fuel for anti-British propaganda in New Jersey.

New Jerseyans also had to contend with ruinous inflation during the war. The value of the Continental currency dropped, causing a sharp increase in the price of consumer goods. Food was available in New Jersey, but the price of meat went up. The British prewar ban on colonial trade and production had resulted in unemployment. Women also despaired over the

epidemics of dysentery, smallpox, and other diseases that accompanied the marching troops. Jemima Condict Harrison recorded in her diary on January 20, 1777: "Well my dear friends what a time it is. A sickly time & a very dieing [sic] time, the people fleeing before the enemies."[9]

Even before the actual fighting began, women were expected to boycott English goods, including manufactured cloth. Those who complied with the boycott spent endless hours at their spinning wheels and looms producing cloth to dress their families. Once the war began women spun cloth for shirts for the soldiers, and saw "their spinnning wheels as weapons." Jemima Harrison wrote in her diary in the winter of 1777: "It is most terrible cold and I am forced to be in the shop for I have to weave. I can't get along without it."[10]

During the war, camp followers traveled with both the British and American soldiers. For the Continental army, they included all classes of women from Martha Washington to officers' wives to soldiers' spouses. Some were prostitutes, but most were married women, sometimes with children, who could not support themselves and their families on either their husbands' military pay or income from farms or businesses damaged by the war. They worked a dangerous and tiring occupation, that of combination field nurse, on-site domestic servant, and army wife. In return, they received half rations and their children quarter rations from the army. General George Washington did not welcome their presence and even considered dismissing them, but feared the desertion of soldiers if he did. He commanded, however, that the women were to follow the baggage wagons and march on foot.

New Jersey's legendary "Molly Pitcher," like many other women, was a camp follower during the war. The daughter of a German immigrant, she was born Mary Ludwig on October 12, 1754, near Trenton. In 1769, at age fifteen, she married John Hays, a gunner in the Pennsylvania State Regiment of Artillery, and traveled with him. The presence of this woman at the battle of Monmouth on June 28, 1778, has confounded many historians. What was she doing at the battle and how did she obtain her nickname?

Mary Ludwig Hays had no children, and followed her soldier husband to war. She earned her way by washing, cooking, mending, nursing, carrying powder and shot, and even swabbing

out the cannons after they were fired. She also carried water to the soldiers on the battlefield on that very hot day at Monmouth Court House. Since "Molly" was a popular woman's name at the time, the soldiers would frequently shout "Molly Pitcher" or "Molly with the Pitcher" when in need of water. Hays became the "Molly Pitcher" immortalized in American history when she took over her wounded husband's cannon and fired it herself. Accounts differ as to whether she fired several rounds or just one. Reportedly, Washington thanked "Molly" for her valor when he reviewed the troops after the battle. Both sides claimed victory at the battle of Monmouth, but victory or no, New Jersey had a heroine and history a legend.

The treatment of Molly Pitcher was an exception. Whatever services women provided the army, they were more often scorned than applauded. "Idle Women" were driven from military camps to the accompaniment of the *Whores March* (a variation of the *Rogues March* used to dismiss vicious or undisciplined soldiers). First Lieutenant William Barton commented with some amusement on one occurrence in 1778. A young woman, in defiance of her father's refusal to let her marry, successfully enlisted in the regiment, disguising herself as a man. Her disguise was not long successful. A captain, Barton reported, "soon made the Discovery by Pulling out the Teats of a Plump Young Girl, which caused Great diversion. . . . I then ordered the Drums to beat her Threw the Town with the whores march they did so which was Curious seeing her dress'd in mens Clothes and (th)e whores march Beating."[11]

Women formed their own patriot organization during the war, the Association of Ladies. This female counterpart of the Sons of Liberty had chapters in Maryland, Delaware, Virginia, South Carolina, Pennsylvania, and New Jersey. Headed by Esther De Berdt Reed of Philadelphia, it sponsored a fund-raising campaign in 1780 and forwarded more than fifteen thousand dollars to General Washington as an "offering of the ladies" in appreciation of the bravery of the Continental soldiers.

The association also published a broadside, "The Sentiments of an American Woman." This patriot propaganda effort was duplicated in New Jersey by women in Trenton with the publication of "Sentiments of a Lady in New Jersey" in the *New-Jersey Gazette* of July 12, 1780. Women were, it said, grateful to the soldiers because "their many sufferings so cheerfully undergone,

highly merit our gratitude and sincere thanks, and claim all the assistance we can afford their distresses."[12]

Voting in New Jersey

On July 2, 1776, two days before the signing of the Declaration of Independence, New Jersey declared the end of British colonial rule and adopted a state constitution that gave "all inhabitants of the colony of full age, who are worth fifty pounds proclamation money" the right to vote.[13] The provision made no gender or race distinction and thereby gave women and free blacks the franchise. It was not intended to make women the political equals of men. As it has been noted, "such a novel extension of the suffrage would surely have elicited considerable debate."[14] Moreover, as one historian pointed out, "a married woman could not claim to be worth 50 pounds since whatever she possessed belonged to her husband."[15] On the other hand, the provision did permit widows and single women worth £50 to vote in New Jersey elections. While no suffrage campaign for the provision preceded its inclusion in the constitution, some historians have suggested that the liberal Quaker attitude in West Jersey, especially regarding the rights and freedom of women, may have influenced political views after the colony was united in 1702.

Between 1790 and 1807, New Jersey women seem to have been permitted to vote in local elections. Election laws passed by the legislature in 1790 and 1797 reaffirmed their right to vote by referring to voters as "he and she." In 1800 legislators rejected an amendment permitting women to vote in congressional contests because they felt it was unnecessary. "Our Constitution gives this right to maids or widows, black or white," said one legislator.[16] Single women went to the polls and voted, casting a quarter of the votes in certain townships. Recent research suggests that only 15 percent of the qualified women voted.[17] Perhaps, voting in taverns and the practice of voice vote for candidates discouraged the new women voters. In any case evidence of women's participation appeared in newspaper articles. On October 19, 1797, the Elizabeth *Journal* reported: "At a late election in this Town women affected the privileges granted them by the laws of this State and gave their votes for members to represent them in the Legislature."[18] In this elec-

tion, seventy-five women of Elizabethtown reportedly voted as a bloc for William Crane, the Federalist candidate to the state assembly. Crane was nonetheless defeated by the Republican candidate, Dr. John Condict, who later opposed female suffrage.

Meanwhile, charges of fraudulent voter registration practices in certain towns began to plague the election process in the state. Married women may have voted even though they did not meet the property requirements (married women could not own property). No estimate was ever made of how many eligible women (single and widowed) lived in the state. William Griffith, a Federalist and critic of women voting observed:

> The great practical mischief ... resulting from their *women's* admission, under our present form of government, is that towns and populous villages gain an unfair advantage over the country, by the greater facility they enjoy over the latter, in drawing out their women to the elections.[19]

Women, regardless of age or status, it was said, were brought to the polls by men and used to influence election results.

The issue of fraudulent votes finally came to a head in the special election in February 1807 in Elizabethtown and Newark to determine the location of a new courthouse. After the election, there were accusations that black slaves, servants, aliens, underaged men, Philadelphians, persons not worth fifty pounds, and married women had voted and were told how to vote. Individuals were charged with duplicate voting. The voters selected Newark as the site of the courthouse, but the election was declared void, because the voter turnout was more than 100 percent of the total population in Essex County.

This incident made it apparent that voter eligibility in state and county elections needed to be reviewed and the election laws examined. However, instead of attempting to enforce or revise the laws, or amend the constitution, the New Jersey legislature passed a law on November 16, 1807, for "the enfranchisement of all free, white, male citizens" with a taxpayer requirement.[20] Thus, New Jerseyans retreated from a position which allowed free blacks, aliens and unmarried white women with property to vote, to one resembling the practice in the other states, that is, white male suffrage. The tempest over suffrage for women may have been less over eligibility, than

over what party might control their vote. Women and blacks were assumed to be easily manipulable.

During the brief period when New Jersey women voted, the legislature made no effort to improve the legal status of women with regard to wills, property, child custody, and education. Nor did women react to the legal change in 1807 with protest in the press or with legislative petitions or demonstrations.

Conclusion

Women of New Jersey made major contributions to the development of the colony. Whether slave or free, they oversaw most of the details of family life, so essential for the colony's economic and political welfare. Though important, their role was largely private. Women played little part in public affairs. With the exception of the Quakers in spiritual matters, New Jerseyans agreed that women were subordinate to men. Unmarried women might conduct business and own property; married women rarely departed from the traditional domestic role. Instances of female autonomy and initiative were unusual.

During the revolutionary war era New Jersey women entered the public arena briefly, participating in boycotts and making an issue of homespun cloth over imported British fabrics and other goods. Female patriotism was a source of pride as women joined their male compatriots in the cause of American freedom. Nonetheless, their wartime sacrifices did not win them equality with men.

Victory over the British did not result in many political gains for American women. No state constitution gave women full citizenship with men. The fact that single and widowed women were permitted to vote in local elections in New Jersey in the postwar period made the state exceptional. The legislators returned New Jersey to the norm in 1807. While the American Revolution changed the complexion of the society, it did little to improve the status of women in New Jersey or elsewhere.

CHAPTER TWO

Home, Factory, and Society

New Jersey retained its agricultural character even as it began to industrialize. The state shared in the nationwide growth of cities and factories, benefiting from advances in commerce, manufacturing, and transportation. While most of New Jersey remained rural, dotted with farms and small villages and towns, what we now think of as the industrial corridor began to develop. Places like Paterson, Newark, and Trenton developed textile, leather, and pottery industries. Banking and insurance firms followed.

Technological advances came slowly. Mills—textile, flour, and cider—still depended on water wheels in the 1830s. While New Jersey had ample sources of water to power mills, these and other industries remained local concerns until the development of canals and railroads. Industry was dependent upon locally available natural resources and businessmen were unable to ship finished products very far or at competitive prices. The development of the steamboat, the use of steam power in industry, and the building of canals and then railroads changed everything. The transportation of passengers and agricultural and industrial products improved in New Jersey when two canals were completed in the 1830s. The Morris Canal ran from Newark to Phillipsburg and the Delaware and Raritan linked Bordentown to New Brunswick. Though the canals were technological marvels, they were outmoded nearly as soon as they were completed. The railroads were faster, carried more freight and passengers, and were not affected by poor weather.

New Jersey's industrial boom faltered with the Panic of 1837. Newark and Paterson, the cities which had benefited the most from industrialization, were hit hard in the depression of the late 1830s. Most of the rest of the state was still agricultural enough to mute the effects of the depression somewhat. When hard times came again in 1857, the misery was more widespread. Though New Jersey was still rural, Jersey City, Camden, Trenton, and Hoboken had industrialized along with Newark and Paterson.

Other changes surfaced during the pre Civil War period. Between 1790 and 1860, New Jersey's population more than tripled, increasing from roughly 184,000 to 672,000. In the 1840s, immigration from Germany increased because of political problems and from Ireland because of the famine. These immigrants were eager laborers and took advantage of New Jersey's economic recovery in the 1840s. Like many native New Jerseyans, they flocked to jobs in factories manufacturing cloth, clothing, shoes, and tobacco products in Newark, Jersey City, and Paterson.

Increasingly, most men no longer worked on farms or in small shops attached to the home. They left home in the early morning to work in factories, stores, or offices, returning at night. Women stayed behind. As full-time homemakers, women no longer assisted in family businesses. No longer did they learn their husbands' trades or occupations, or assume them when the men traveled or died. In general, industrialization contributed to more rigidly defined roles for men and women.

Safeguarding the Home

If women were not to have the same political rights as men, what share of the new republic would be theirs?

Women did not have an acknowledged role in the *public* arena. Their role was domestic rather than public. Just as during the Revolution their patriotic service had been confined to the production of cloth, the boycott of goods, and the nursing of the wounded (extensions of domestic responsibilities), their service to the new republic was as wives and mothers. The "Republican mother," devoted to the service of family and state, produced good citizens for the republic. She nurtured honest

and virtuous sons who would help keep the new nation on a moral path.

In large part, what impetus there was for educating women (almost always middle- or upper-class women) in the young nation was fueled by the belief that they played a major role in the production of good citizens. How could a woman do that without being educated herself? Even so, many people resisted the idea of educating a woman beyond needlework, music, and other skills which might fit her for marriage. The debate turned on whether education would make a woman unfeminine. Would an educated woman abandon her proper sphere, a sphere few would dispute was domestic?

An early interest in advancing the intellectual training of women is evident in an 1826 address by the Reverend H. P. Powers at an anniversary celebration of the Newark Institute for Young Ladies. He decried the contemporary level of female education as substandard and, while not promoting the same caliber of education for men and women, he observed that women needed more studies in the moral sciences and theology. To raise children properly, declared Powers, the intellectual attainment of a woman should be improved: "Her sphere of action, and her greater leisure, bring her more into social intercourse where the rules of ethics which govern society are called for." On women's role in relation to men, he recommended the following:

> If a man's object in marriage is to obtain a bosom companion, one, whose heart not only beats in unison with his, but one with whom he may share the literary banquet ... how desirable is it that young ladies destined for the companion of literary men, should be fitted for the station by receiving an education far transcending the meagre attainments of the day.[1]

Improved education of women in New Jersey was provided by female seminaries and academies (sometimes supported by local subscription). These private, sex-segregated tuition schools for girls fulfilled the aims of republican motherhood. The best known of them was the Young Ladies' Seminary at Bordentown, which published a prospectus in 1836 indicating its intent to emphasize "the forming of a sound and virtuous character."[2]

The girls' academies provided much of the secondary schooling for daughters of the middle class.

The seminaries taught a rigorous academic curriculum along with the "feminine arts" of music, language, and needlework. School authorities supervised the conduct, morals, table manners, and religious observances of the students. One church-related girls' school, St. Mary's Hall in Burlington, founded in 1837 by Episcopal Bishop George Washington Doane, promised "the best teachers in every department of science, literature, and the fine arts proper to such an institution."[3]

As early as the 1790s, a number of girls' boarding schools had opened in New Brunswick. The curriculum emphasized such gender-specific subjects as needlework and homemaking. The schools attracted girls from Elizabethtown and even New York, Philadelphia, Kentucky, and New Hampshire. A "female academy" was also started at Queens College (now Rutgers University) about 1805 with the endorsement of individual (male) members of the college's board of trustees. Its advertisements professed a trend away from a school for the domestic arts to one with a curriculum comparable to the boys' academies.

The Brunswick Hill Boarding School, founded by a group of women in New Brunswick in 1821, emphasized manners and morals or "ornamental branches" of study for girls. Another school of this type that opened at around this time was Mrs. Bell's School for Young Ladies, which lasted about fifty years. New Brunswick also boasted the most prominent girls' seminary in the state, founded in 1839 by Hannah Hoyt, known as a disciplinarian, intellectual, and superb teacher and administrator. She offered a curriculum of Latin, Greek, history, algebra, geometry, astronomy, logic, and philosophy. When the school ran into financial troubles, the city fathers provided the funding for its continuation.

These and other women's seminaries flourished in New Jersey at a time when the public-school movement was in its infancy. While the schools offered a variety of subjects, they shared a common purpose—preparing women of sound character who would instill republican virtues in their sons. The female seminaries produced a supply of teachers for schools of all types throughout the state. At first, few schools could be called public.

Nineteenth-century New Jersey's record in public education

was not very impressive. A majority of the schools in the state were private tuition schools; the rest were parochial and "pauper schools." The state constitution of 1776 made no provision for education, leaving it to private interests as in the colonial era. The state legislature provided little leadership in establishing common or public schools. In 1817 it did create a state school fund for public education, supported by public securities. This was really the first step taken to establish a public common-school system, but townships received no funds until 1829. Also in 1816, the legislature passed the first comprehensive school law requiring an annual appropriation of school funds. In 1820 the legislature authorized the townships to raise money for education, but still only for those too poor to pay the rates. Until the late 1830s public education remained synonomous with pauper schools and the kind and amount of education was left to individual communities. Thousands of children received no education at all because their parents found it too humiliating to be classed as paupers and didn't send them to school. The first truly free school was not established until 1844 in Nottingham.

Some girls' schools, such as the one founded by the Female Union School Association (established in Newark in 1822), relied on charity. Subscribers to the society founded a free school "for the promotion of learning, industry, morality and piety among the indigent female children of ... [the] town."[4]

In general, the public elementary-school curriculum was the same for boys and girls: it emphasized reading, writing, arithmetic, and moral training. Most secondary schools had separate curriculum and classroom facilities for boys and girls, reinforcing the prevailing notion of career preparation for one and domestic preparation for the other. The educational establishment, for the most part male, still debated whether girls had the intellectual ability to learn certain subjects, whether studying those subjects was simply a waste of time, or even whether their study might somehow damage young women as potential wives and mothers.

Public support for education was bolstered in New Jersey with the new state constitution of 1844, which secured the continuation of the state school fund and the distribution of the income to school districts. State supervision of the common schools came in 1846 with the establishment of the office of State

Superintendent of Public Schools. But it was not until 1871 that a free public elementary-school system prevailed in the state. The experience of Clara Barton demonstrated the significance of public education.

Clara Barton

Clara Barton (1821–1912) arrived in New Jersey in 1853 for a visit with some Bordentown friends. The Massachusetts schoolteacher's visit turned into an extended stay when she was offered a teaching post in the local school. Barton discovered that most of the town's children did not attend school; their parents could not afford to send them to the private school in town and were too proud to send them to a "pauper school" supported by the local poor tax.

She convinced the Bordentown school board to open a free public school, agreeing to teach without salary for three months in a refurbished one-room brick school house. The Bordentown school was one of the first free public schools in New Jersey and in the nation. The experiment's success was made evident by the early need to construct a larger school. Barton later remarked:

> Something drew me to the State of New Jersey. I was a teacher dyed in the wool, and soon discovered that this good state had no public schools, that a part of its children were in private schools, the remainder in the streets. . . . They had public school laws, but not enforced.[5]

In two years, enrollment at Barton's school grew from six to six hundred. Bordentown had been happy to let Barton build the school, but once she had made the school so large, the authorities decided that it should be run by a man. When a male principal was chosen, Barton, who after twenty years of teaching was experiencing difficulties with her voice, resigned her post. She left New Jersey and later became known for her work as a nurse during the Civil War and as organizer of the first Red Cross Society in America.

Barton's school provided the inspiration for the founding of more public schools in New Jersey. By 1855, twenty-nine townships boasted free schools. In the same year the first public high school with a separate "female department" on the second floor

opened in Newark, and a normal school (a school for teacher preparation) opened in Trenton.

The demand for teachers created by the increase in the number of free public schools provided a host of opportunities for women, although the pay was not good. The view of women as bastions of purity, inculcators of virtue, and respecters of authority made them seem ideal teachers. School boards found even more attractive the fact that women teachers could be paid lower wages than men. In 1858, the average yearly salary was $393 for male teachers and $237 for women. This inequity in teacher salaries continued well into the twentieth century on both the state and national levels.

Domesticity and Femininity

By the 1830s, the portrait of women as educators of citizens for the young republic had changed. Women were still expected to impart moral values to their children, but the emphasis was less on training patriots than on being models of purity. The home became a sanctuary, a needed refuge from the larger society.

Popular literature, the new women's magazines, and even sermons emphasized domesticity as well as piety, purity, and submissiveness. A number of historians have since referred to this literature as promoting the "cult of true womanhood" or the "cult of domesticity."[6] Women, at least the middle- and upper-class women at whom the literature was generally directed, were supposed to be ideal creatures wholly devoted to home and family.

The family was a distinct social system, apart from the world of politics and commerce. The woman guarded the sanctity of the home, and had full responsibility for all aspects of household management. Her greatest achievement was providing a warm, comfortable home that was clean and inviting. The home was both a refuge for a man trying to make a living in a sometimes corrupt world, and a protected environment for children.

Very few people questioned the division of roles or minded that women could not operate in the world of business on an equal footing with men. Much of the popular literature, in particular the marriage manuals, was written by women. Since it was a given that women had few alternatives to a domestic

role, it was in their interest to stress the importance of that
role. Whether or not women wielded power inside the home,
women's literature encouraged the belief that they should.

> Were each American female but faithful to her God, her family,
> and her country, then would a mighty sanctified influence go
> forth ... diffusing moral health and vigor.... A spirit of in-
> subordination and rebellion to lawful authority pervades our
> land—and where are these foes to be checked, if not at the
> fountain head, in the nursery?[7]

Women became consumers of the manufactured goods of the
emerging industrial economy. Granted a measure of leisure
time, women had the opportunity to experiment with fashion
by patronizing millinery shops and dressmakers and to join
church groups, sewing circles, and reading groups.

In the rural households of New Jersey, the work of farm
women remained much the same as it had been during the
colonial and Revolutionary eras. Farms remained self-contained
enterprises and women continued to produce clothing, help
produce food, and to perform the tasks of homemaking and
childcare. Even their social life involved work. Rural women
and their friends met to quilt, sew, and weave and manufacture
soap and candles. The burdensome tasks of keeping a house
with uncarpeted floors, caring for poultry and dairy animals,
and coping with an open fireplace continued for most of the
nineteenth century. After the 1830s, however, the anthracite
coal stove replaced the woodburning fireplace in most homes,
and food preparation became easier.

Farmers' wives contributed to the economic efficiency of the
farm operation well past the point when large-scale farming and
scientific agricultural practices had been introduced. The loss
of small farms during the depression of 1837–1840 forced many
women and men off the farm and into factory towns to look
for employment.

"Mill Girls"

Despite the middle-class cult of domesticity, many New Jersey
women worked outside the home. For poor women, in-
dustrialization made the idea of separate spheres irrelevant. As
one historian has noted, opportunities for women were limited.

"As late as 1840 the only types of employment open to women were teaching, keeping boarders, needlework, bookbinding, typesetting, household service, and work in cotton mills."[8] Married women worked when their husbands' income proved inadequate, and single women worked to supplement their families' incomes until they married. However, all employment of women—even of those who worked from necessity—was regarded as temporary. Most working women labored in low-paid, unskilled jobs into the twentieth century. Women's employment was neither highly respected nor encouraged because men believed women would compete for men's jobs and thereby reduce wages for all. In New Jersey, there was little labor legislation regarding women and children, and mandatory school attendance laws were poorly enforced. Women and children were badly exploited in the workplace.

Women's employment—spinning yarn and weaving cloth in textile factories, teaching, nursing, domestic service, and taking in boarders—was seen as an extension of work they performed in the home. A growing demand in northern cities for cheap ready-made clothing and for wholesale merchandise created work for poor women in sewing shops and factories. Men resisted female membership in trade unions, fearing that women workers would hurt their cause by competing for their jobs and working for lower wages. Instead of allowing women to join with them in unions working for their mutual benefit, male workers fought to keep women in the less-skilled and poorer-paying jobs. In some industries, male resistence lasted well into the twentieth century.

The first cotton mills in New Jersey were established in Paterson in the 1820s. Most of the workers in New Jersey cotton mills were women and children. Labor historians have described not only horrendous work conditions, long hours and low pay, but also the militancy of women workers who struggled with their male counterparts to attain more money and shorter hours. The first recorded work stoppage of the era occurred in Paterson in July 1828. When the employers in a cotton mill changed the lunch hour from noon to one o'clock, a large number of children, afraid the lunch hour would be eliminated altogether, walked out of the mill.

Laborers in town as well as parents of the children endorsed the strike and extended the struggle to seek a ten-hour day for

all workers. When the strikers heard that the employers had called for the militia in Newark, the workers went back to the mills, and the company restored the noon lunch hour. Though the strike failed (as did others during the period), employers were served notice that they could not change work conditions without worker response and that both women and men workers could and would strike.

Mill workers, mostly women and children, worked a thirteen-and-a-half-hour day which was standard in the Middle Atlantic states, and they feared reprisals such as wage reductions and dismissal if they were late or absent. In July 1835, workers at twenty cotton mills struck for the eleven-hour day, nine hours on Saturday, cash wages rather than scrip for the company stores, and overtime pay. During the six-week strike, the workers joined the Paterson Association for the Protection of the Working Classes, which received funds from workers in other cities for the strikers. Although strikebreakers ended the strike, it did achieve a shortened workday of twelve hours for weekdays and nine hours on Saturday and left the tradition of union association open to these workers.

Labor strikes in New Jersey, as elsewhere, seemed to subside with the decline in the national economy and the closing of many factories during the depression of the late 1830s. When the mills reopened in the succeeding decade, women returned as temporary workers to support families hurt by the loss of farms. Their presence in the work force coincided with early demands for women's rights and various middle-class women's reform work.

The mechanization of certain crafts also affected the employment of women. One study of industrialization in Newark before the Civil War found that in occupations which formerly required hand sewing, women were replaced by men who ran sewing machines. Women might be hired as hat trimmers or shoe binders, but they lost out in the general manufacture of shoemaking and hat making and were paid less than men in those industries. Women also lost jobs to skilled male machinists when linotype machines were brought into the printing industry. Not until women mastered factory skills did they return in large numbers to the newly mechanized industries. According to the Newark work study, "Victorian tradition dictated that mothers

belonged at home and that young girls should learn domestic skills not factory jobs."[9]

Even so, single women found employment in Newark factories more readily than married women did. "According to the 1860 population census, only 2 percent of the women in the crafts were married and living with their spouses. Manufacturers did not hire many widows or deserted wives either; only 7 percent of the women workers had children."[10] Employers viewed married women as less desirable employees, even though they worked for less than single women, because they thought their family responsibilities made them less dependable. Wages were also low for single women in their late teens because they usually lived at home and were not sole supporters of families.

Slavery and Slave Women

The lives and work of New Jersey's African-American women, slave and free, are difficult to summarize. One may assume that slave women performed whatever work was requested by their masters. Free black women led varied lives. Most were poor, and all faced rampant racism. Most free blacks found employment as teamsters, laborers, domestic servants, or washerwomen in the cities. For the most part, they performed menial tasks for low wages; the more lucrative factory jobs were closed to them.

New Jersey provided for the gradual abolition of slavery in 1804, specifying that the offspring of all slaves born after July 4, 1804, should be free. They would remain the servants of the masters of their mothers until the age of twenty-one if female and twenty-five if male; they were not slaves but they were also not quite free. The plan assumed that children of slaves raised to be free would make an easy transition from bondage to emancipation.

In 1810 New Jersey had 10,900 slaves, and in 1830 it had 2,300, or more than 80 percent of the 2,800 slaves living in the North.[a] In the next decade the number dropped dramatically to about 700, or less than 1 percent of the state's total population. In 1846, the legislature passed a second emancipation law. Enslaved blacks became apprentices for life; their children were

[a] New York, Pennsylvania, New Jersey, and the New England states.

free. New Jersey population figures of 1850 report an African-American population of about twenty-four thousand, most of whom were free. In 1860 the federal census listed eighteen slaves in the state.[11] If any slaves remained in New Jersey after the Civil War, they were not free until ratification of the Thirteenth Amendment in December 1865.

Against this legal and statistical background, the lives of several New Jersey slaves have been documented. Silvia Dubois, Elizabeth Sutliff Dulfer, and Betsey Stockton each shared the common heritage of bondage and each lived a life of courage.

Silvia Dubois, born a slave in Hunterdon County in 1768 and named after her mother's master, could neither read nor write. However, she left a narrative of her life, *A Biografy of a Slav Who Whipt Her Mistres and Gand Her Fredom,* transcribed from phonetic spelling.

Dubois was separated from her mother, Dorcas Compton, when she was acquired by a different master. She worked for Dominicus Dubois at numerous occupations including domestic worker, ferryboat operator, and farmer. However, she clashed with her mistress, was beaten, and retaliated by seriously wounding the woman. She convinced her master that New Jersey law gave slaves the right to find new masters if they were not compatible with the old ones. He conceded the severity of the situation and gave Dubois a written pass to flee. Dubois fled, and was later reunited with her mother. She worked as a paid laborer and eventually inherited a tavern built by her maternal grandfather, a manumitted or freed slave. She had six children and lived to the reported age of 120.

Dulfer, born in slavery in 1790 in Bergen County, was manumitted by her master in 1822, but it is not clear whether she purchased her freedom or if it was granted by her master for her work. Dulfer operated a successful farm with her husband, the proprietor of a clay business, and also invested in real estate.

Betsey Stockton, born a slave in 1798, was freed in 1818 by her master, the Reverend Ashbel Green, the president of the College of New Jersey (later Princeton University). She continued to work as a domestic in the Green household until 1822, when she traveled as a missionary with a white family to the Sandwich Islands (Hawaii). Stockton returned to Princeton in 1833, helped found the Witherspoon Street Church

(Presbyterian), taught black children in a public or common school, and promoted a night school for black adults in the Princeton community.

Early Reformers

New Jersey abandoned its property qualification for voting in a new state constitution in 1844, adding New Jersey to those states which constitutionally granted universal white male suffrage. This meant that "every white male citizen of the United States of the age of twenty-one years, who shall have been a resident of this state one year could vote."[12] Black men and all women, white and black, were denied the right to vote and were placed in the same category as soldiers, sailors, paupers, and the insane. All were relegated to a lower class of citizenry. Race, gender, impermanency of address, or poverty made an individual as unfit to vote as did mental impairment.

The state barred all women from voting, but it made a small improvement in the legal position of married women a few years later. Following the lead of New York and Massachusetts, New Jersey enacted the Married Women's Property Acts of 1852 and 1865. These laws permitted married women to make contracts and wills, the same property rights enjoyed by single women.

A number of reform movements gained strength in the period before the Civil War. Ironically, society's view of women's proper role as domestic supported their reform activities. Women reformers from the mid-nineteenth century to the Progressive period used the language of domesticity—moral housecleaning—in their efforts to improve child welfare and education, abolish slavery, achieve the prohibition of liquor, improve sanitation, and secure the passage of pure food and drug laws. In New Jersey, as elsewhere, many of these reformers were middle- or upper-class women from Protestant evangelical backgrounds. Methodists, Presbyterians, Baptists, and Quakers tried to raise society's moral level by good will and charity or by legislating morality.

Many of the reform organizations and charitable societies they joined had begun as church organizations, and some maintained loose church affiliations. These voluntary societies sought moral reformation of society through indoctrination or legislation. Their goal was twofold: Make the poor self-sufficient and

society moral. Charity was tempered by the drive to achieve social control.

The model for New Jersey's benevolent societies was the Newark Female Charitable Society. This society, the oldest of its kind in New Jersey and the third oldest in the nation, was founded by Rachel Bradford Boudinot in 1803. She and her women associates from the Old First Presbyterian Church organized a society to help the sick, the aged, the unemployed, widows and dependent children. Dedicated to helping the poor help themselves, the society served as Newark's premier social-reform agency during the Progressive era and continues to operate today.

The Female Charitable Society of Morristown was another important nineteenth-century benevolent society. Louisa Macculloch and other women from prominent families organized the society in 1813 to provide both relief and training to the local poor. The dues and donations they collected bought food and clothing and subsidized instruction for poor women in spinning and weaving. The society extended its service to poor native white, freed black, and Irish immigrant families.

Even though they could neither vote nor hold office, many New Jersey women were politically active, usually on behalf of the dispossessed. Their reform activities reflected a concern for women, children, blacks, and the poor in the often harsh world of the nineteenth century.

Dorothea Dix

Foremost of all reformers of the pre Civil War period was Dorothea Lynde Dix, a former teacher from Massachusetts who challenged the manner of institutional care of the mentally ill. Beginning with her home state, she began a study of jails, hospitals, and asylums in several states. After reviewing the various facilities she presented a memorial or report to the appropriate state legislature, specifying the poor conditions she had observed. She was especially concerned about the care of the mentally ill in inhumane "insane asylums." In her reform plan, she adopted the view of Dr. Philippe Penel of France, who contended that mental illness could be cured in some cases.

Dix visited several institutions in New Jersey in 1844. Her memorial to the state senate in January 1845 pointed out that

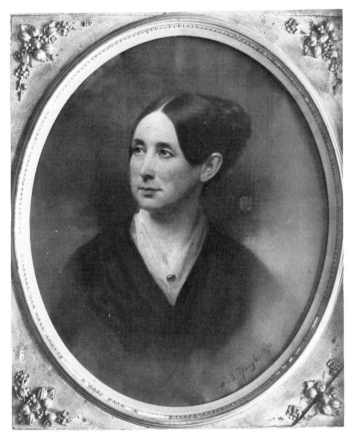

Dorothea Lynde Dix (1802-1887). A leader in the nineteenth-century effort to provide humane care for the mentally ill. Courtesy TRENTON PSYCHIATRIC HOSPITAL.

despite a large number of mentally ill persons, the state had neither constructed a special state hospital nor sought the latest therapy for the patients. The mentally ill were traditionally among the state's poorest inhabitants, and the cost of their care exceeded the resources of either their families, their churches, or their towns. To improve the situation, she recommended the establishment of a state hospital which would properly house and treat the mentally ill.

Dix began her drive for a state hospital with an intense public-relations campaign. First she had to convince both health officials and the public that mental illness was better treated in a hospital than a prison. Then she had to persuade legislators that spending state funds for a state hospital would have long-range value. This required considerable political skill. Within three months Dix had succeeded and the legislature passed the necessary bill. Her biographer, Helen E. Marshall, believes Dix became especially fond of the hospital in New Jersey and its potential for the patients:

> She delighted in poring over the architect's drawings ... She liked to think of it as situated on the top of a hill in the center of a grove of trees ... In such a happy setting she thought that sick and turbulent minds could not but find peace. She had worked so hard to secure this institution that it seemed an infinite part of her being, and it would always be so.[13]

Other middle-class reformers experimented with utopianism in New Jersey. The North American Phalanx (1845–1856) in Red Bank was a nonsectarian community that professed religious toleration, profit sharing from the sale of farm produce, free education, and the absence of discrimination on the basis of age or sex. Women supposedly helped set policy and spoke in the community's public assembly; in theory all categories of work were open to them. However, researcher George Kirchman questions the claims of sexual equality at the Red Bank Phalanx. He reports that women were paid less than men, worked predominantly at traditional domestic chores, and possessed little influence in the community.[14]

Another cooperative society, the Raritan Bay Union near Perth Amboy (1853–1859), established a coeducational and racially integrated boarding school called Eagleswood Academy (1854–1861). Boys and girls attended the same lectures, went on field trips together, and received the same instruction, including physical education, agriculture, art, music, housekeeping, and woodworking. To operate the academy, founder Marcus Spring and his abolitionist wife Rebecca Buffum Spring recruited the abolitionists and women's rights advocates Theodore Weld as director and Sarah and Angelina Grimke as teachers. The school drew students from all over the country.

It was noted for its curriculum and for famous guest lecturers such as Ralph Waldo Emerson and Henry David Thoreau. Located on the Raritan River, Eagleswood also became a way station for fugitive slaves escaping on barges to Canada. Rebecca Spring visited imprisoned abolitionist John Brown after his unsuccessful attack on the federal arsenal at Harpers Ferry, Virginia in 1859. Spring's befriending of Brown was extremely controversial in New Jersey. To those New Jerseyans sympathetic to the South and opposed to abolition, Brown was a figure of evil. That he attacked a federal arsenal offended many opponents of slavery as well. For many New Jerseyans, Brown and his followers were traitors rightly condemned to death. There was considerable public outcry when Spring buried two of Brown's followers at Eagleswood, fulfilling a promise to bury them in free soil.

The area of reform that attracted the most support from women crusaders was the abolition of slavery. Those who participated in the movement generally favored the immediate emancipation of slaves rather than gradual abolition which New Jersey had undertaken in 1804. Many participated in the "Underground Railroad," a system of escape routes used by slaves fleeing the south for northern states or for Canada. In New Jersey, the so-called depots existed in places like New Brunswick, Camden, Salem, Greenwich, Burlington, and Bordentown. The homes and property of abolitionists served as "stations" to hide fugitives on their way to freedom. Sydney (Charity) Still escaped from Maryland to join her husband, Levin Still, in Mount Holly with the assistance of the Underground Railroad. Trenton, Burlington, and Salem Quaker abolitionist societies, among others, actively participated in the transport of fugitive slaves north to freedom. New Jersey could be a dangerous escape route for fugitive slaves. The state was one of the few in the North that permitted runaways to be captured and returned to the South.

Few of the women involved in the abolitionist movement are known. The abolitionists used code names to protect themselves from proslavery supporters and prosecution under the fugitive slave laws of 1793 and 1850. Abigail Goodwin, a Salem Quaker, is one of the few whose name we do know. She worked for abolition in southern New Jersey through the Philadelphia Female Anti-Slavery Society for over twenty years. Called "one

of the rare, true friends of the Underground Rail Road," she hid fugitives in her home and at personal sacrifice provided them with food, clothing and money. On soliciting for funds for the slaves, she wrote in 1858, "Oh that people, rich people would remember them instead of spending so much on themselves." A dedicated abolitionist, Goodwin "worked for the slave as a mother would work for her children."[15]

When the Civil War began, New Jerseyans were deeply divided. New Jersey was the only northern state that did not support Abraham Lincoln in the 1860 presidential election. Some New Jerseyans supported the Union cause as an outgrowth of their work for abolitionism. Others viewed the war as disruptive and believed the South had a right to secede. Commercial investors and urban textile workers were anxious about the future status of slavery and its impact on employment. Not only did the South supply the state's textile mills with cotton, but a large percentage of the men's clothing and shoes manufactured in New Jersey was sold in the South.

The war disrupted family life, brought economic deprivation and shortages of foodstuffs, medical supplies and other necessities, and required considerable sacrifice both on the home front and on the lines. Much of the task of dealing with the domestic economic burden fell on women. They also served close to the fighting. The Union government established a professional nursing corps, headed by Dorothea Dix, under the United States Sanitary Commission. Women did paid nursing for the military in the Union and Confederate armies as well as in volunteer hospitals, and participated in local soldiers' relief society work.

On the home front, New Jersey's working-class women found war-related employment in mills, arsenals, and munitions factories. The shortage of manpower brought women into government offices as clerks and typists, into stores as sales personnel, and into private and public schools as teachers—but at lower wages than their male predecessors. Wealthy women responded to the war crisis by founding civilian relief organizations and conducting fund-raising events to aid the poor and sick. Newark women founded a soldiers' relief society in April 1861, and women in Camden began the Ladies' Aid Society and Ladies' Relief Association. Women's aid societies throughout the state purchased or collected clothing, blankets, stockings, and other

supplies for the soldiers. Many of the societies were organized by churches and involved women of all social classes. They also raised over $1.8 million for the commission through the Central Fair of the Sanitary Commissions of the States of New Jersey, Pennsylvania, and Delaware, held in Philadelphia on June 7, 1864.

New Jersey women took care of wounded soldiers in and out of the state. In May 1862, the federal government established a hospital in Newark for wounded soldiers from New Jersey, and the town's women provided food and other supplies to several hundred patients there. Other women served in hospitals out of state, primarily near Washington, D.C., or worked as field nurses.

Cornelia Hancock, a Salem County Quaker, had the most distinguished record of service. She was the first woman to arrive to care for the wounded at the Battle of Gettysburg. Hancock traveled with the Twelfth New Jersey Regiment as an assistant to her brother-in-law, Dr. Henry T. Child of Philadelphia, and provided care in various field hospitals for both soldiers and escaped black slaves. Her total dedication to those in her care earned her the title "the Florence Nightingale of America."

Other New Jersey women at the battlefront included Hettie K. Painter of Camden, a field nurse at the Second Battle of Bull Run and the Battle of Fredericksburg; and Virginia Willets Stradling, also of Camden, who served as a volunteer nurse in the Army of the Potomac and later was in charge of the hospitals at Fredericksburg and at Port Royal.

Fanny Wilson chose another role. She was one of approximately four hundred women who disguised themselves as soldiers during the war. Before her ruse was discovered, she served eighteen months with the Union army and was wounded at the Battle of Vicksburg. She was discharged, only to reenlist and be discharged a second time.

Conclusion

During the early years of the nineteenth century, most women confined their activities to home and family. As New Jersey developed industrially, many women began to work for wages outside the home. Class, race, and ethnicity determined what

kind of work they did and when they did it. Single white women worked to help out their families until they married. Many white women who remained single and widows labored as domestic servants all their lives; others found factory employment. Free black women had few employment opportunities beyond domestic service or as laundresses. All of these women worked because they had to, not because they chose to.

Most upper- and middle-class women stayed at home while their men went out to work. Supported by the labor of domestic servants, these women made their homes refuges from the corrupt world of commerce and politics. Gradually they began to fill their leisure time with volunteer charity and church activities, a socially approved extension of domesticity. They were engaged with the community on a host of issues, including education, health, abolition of slavery, and poverty. Eventually, society's acceptance of these endeavors as appropriate activities for women provided employment opportunities in teaching, nursing, and social services.

The concept of separate spheres for men and women remained an ideal in American society, but began to lose some of its rigidity after the Civil War. Changes in the nation's social, political and economic environment began to challenge many of the limitations of gender-specific roles.

WOMEN'S CLOTHING AND WHAT IT MEANS

Dress can provide a great deal of information about people and the society in which they live. It furnishes clues about occupation, wealth, and social status. What women have worn during the periods covered by this book tells us something about their place in the world.

Until relatively recently women were legally inferior to men. They did not work outside the home; they were expected to marry and raise a family. Early on, a woman who did not marry might face an uncertain future.

Women's clothing made this restrictive role clear. It was more physically confining than men's. Even the eighteenth-century farmwife who helped her husband in the fields wore a long skirt and petticoat. Women's clothing had more bulk and more layers than men's, and it was surely more uncomfortable. The more women were regarded as delicate creatures in need of protection, the more elaborate did their clothing become, at least in the middle and upper classes. Fashionable women's clothing was at its most elaborate in the late nineteenth century. Wealthy women changed their outfits frequently—four or five times a day—to match a rigid schedule of social activities. Major portions of an upper-class woman's day were devoted to personal adornment.

Wealth and lifestyle have always affected the size and content of a woman's wardrobe. Fashionable colonial American women tried to follow European clothing styles. From 1750 to about the Civil War, imported "fashion babies" or dolls dressed in the latest styles helped them keep up with European fashion. Beginning around 1830 illustrated magazines such as *Godey's Lady's Book* provided American women with drawings and sketches of fashionable clothes.

The basis of the eighteenth-century costume was the che-

mise,[a] the forerunner of the modern blouse. A closely fitted corset-bodice[b] or jacket and a separate petticoat[c] were worn over the chemise. Stockings, a kerchief tucked into the bodice, shoes, an apron, a mob cap,[d] and a long cloak for traveling completed the basic costume. The apron served both a practical and a decorative function. Like the chemise, the aprons might be embroidered or trimmed with lace. Although men wore drawers, women wore no lingerie. What we think of as women's underwear is a late nineteenth-century invention.

Wealthy women had access to many fabrics, both domestic and imported—fine linen, cotton, woolen broadcloth, silk, satin, and velvet. Their chemises might be embroidered and trimmed with lace. Stays made of whalebone and hooped petticoats assured a fashionable fit—a long slim line, small waist, and full skirt. Pockets were separate from the skirt and hung from the waist on tapes. Gloves of cotton, silk, or leather, stockings of cotton or silk held by garters, fans, muffs of feather or fur, rings, necklaces, and (after midcentury) earrings were the basic accessories.

Women of more modest means made their clothing of homespun cloth such as wool or linsey-woolsey (a combination of wool and linen). There were obvious distinctions between their clothes and those of their wealthier neighbors. They were made of poorer, rougher fabrics, their color range was limited

[a] A one-piece undergarment that reached from the shoulders to knee level or below. It was worn beneath the corset-bodice, and its sleeves and neckline showed as part of the dress.

[b] A corset is a close-fitting boned supporting undergarment hooked or laced in front and/or in back. It extended, depending upon the period, from above or beneath the bust or the waist to below the hips. It could also be worn as an outer garment, laced over a chemise. As an outer garment it formed the bodice or upper part of a woman's dress. Bodices and skirts were usually separate pieces.

[c] An underskirt made of cotton, linen, flannel, wool or silk. Several might be worn, either for warmth or to make a full skirt stand out. For certain types of dresses, for example some eighteenth-century dresses, the petticoat showed as part of the dress.

[d] A close-fitting cap of linen, often trimmed or ruffled, worn in the house.

(no elaborate patterns or embroidery), they were not as up-to-date in terms of style, and they were not as well made. The busy farmwife beset with many household tasks had neither the time nor the skill to fit clothes as expertly as a seamstress or tailor. In addition, farmwives and servants did not wear hoops.

Most American women had very limited wardrobes. They might have two or three dresses, one "best" for church or meetings, the others for ordinary work. Most women slept in their daytime shifts (chemises) or in nothing at all; a few had nighttime shifts. Poorer people often wore no shoes in warmer weather. Leather shoes were both expensive and scarce.

The fascination with classical themes between the American Revolution and around 1820 had its influence on dress. Fashionable women wore simple frocks (made of very expensive fabric) which did not require the tightly laced stays of the eighteenth century. Dresses were slim and high-waisted, and they clung to the body. This fashion lasted only a brief period.

For the remainder of the nineteenth century, women's clothing was voluminous and elaborate, and it required very tight corseting. Women's wardrobes grew, both in numbers of dresses and in sheer volume of each individual dress. The development of the textile industry both in Britain and the northeastern United States made large quantities of manufactured cottons and linens available for purchase. Women, except for the very poor, could abandon the tedious tasks of spinning and weaving. Also by the 1820s, fewer Americans went shoeless. The recently developed New England shoe industry provided shoes for Americans of all classes, though the shoes fit poorly. Standard sizes of shoes and clothing came much later—in the early twentieth century. Some ready-made clothing began to appear in the 1840s (it was partially put together). Ready-made clothing for men was available earlier than for women. Wealthy American women and those with more moderate incomes wore similar styles of clothes, but the fabric, detailing (lace, ribbons, tucks, etc.), and size of the wardrobe clearly indicated who was wealthy. The development at midcentury of the foot-treadle sewing machine and the sewing pattern made making clothing far easier for both the home sewer and the seamstress.

The availability of inexpensive cloth meant that women could have more clothes by the 1830s and 1840s, several dresses instead of two or three. Their wardrobe was not only larger,

it was cleaner. Because Americans had more clothes, they could
change them more frequently. Clothing could be washed more
often. Washing clothes was a major chore; water had to be
hauled and then heated. The impetus for the construction of
city water systems in the first half of the nineteenth century
was the need to remove sewage from the streets and assure
drinking water, not to provide water for laundry and bathing.
Most working-class Americans were still hauling water for laun-
dry and bathing when World War I began.

Detachable collars and cuffs were one avenue to a neater
appearance for both women and men in the nineteenth century.
Collars and cuffs, which got dirty first, could be washed after
each wearing. The shirt, which stayed visibly clean, could be
worn more than once before washing. Clean collars and cuffs
demonstrated that one did not work with one's hands and clean
hands were associated with gentility. The wearer had servants
to do the housework or had a "white-collar" job.

Middle- and upper-class women led highly domestic and
ordered lives. Their clothing was multilayered, heavy, and con-
stricting. The ideal woman had a tiny waist and large bust and
hips. What nature had not provided, artifice did in the form
of tightly laced corsets, stiffened petticoats, bust enhancers, and
bustles.[e] Nineteenth-century clothing was an aid to both prudery
and eroticism. Women kept bust, hips, and buttocks well cov-

[e]A steel or horsehair supporting garment worn at the back of the skirt.
It varied in size from a small pad to a large shelf.

*Maid's attire, mid-eighteenth century (a); dress of middle to upper-class
woman, 1725-50 (b); gown, ca. 1812 (c). While the first two costumes
share certain characteristics (apron, crossed muslin scarf, and jacket or
robe over underskirt), the maid's attire is far less elaborate, made of less
expensive fabric, and is certainly easier to work in. The early nineteenth-
century dress is a simpler one-piece costume of neo-classical lines. A &
B, reprinted with permission of CHARLES SCRIBNER'S SONS, an
imprint of MACMILLAN PUBLISHING from* Five Centuries of Ameri-
can Costume, *by R. Turner Wilcox. Copyright ©1963 R. Turner Wilcox.
C, reprinted with permission of NEW AMSTERDAM BOOKS (US) and
THE HERBERT PRESS LTD (UK) from* Fashion in Costume,
1200-1980, *by Joan Nunn. Copyright ©1964 Joan Nunn.*

a

b

c

ered by multiple layers of clothing, but wore bust enhancers and bustles to call attention to those features. Underclothing, which in theory was never seen, was beribboned, trimmed with lace, and embroidered. Ankles and legs were covered, but stockings and petticoats might be brightly colored, patterned, or trimmed. When women walked, the flash of color or lace drew attention to the ankles. The corsets prevented women from bending or even sitting comfortably. The wearer could take only shallow breaths because the diaphragm was so constricted. Men were believed to find the fluttering of the bosom erotic.

Until the middle of the nineteenth century, women's dresses featured tight bodices, large leg-of-mutton sleeves,[f] and very long, full skirts, all of which accentuated a tiny waist. Men supposedly found the swaying skirts alluring; Dorothea Dix, the Superintendent of United States Army Nurses during the Civil War, forbade her nurses to wear crinolines[g] (she also wanted very plain-faced nurses) to prevent romantic attachments between nurses and wounded soldiers. Full skirts had other uses. The fledgling spy industry on both sides in the Civil War found that women spies could easily hide all sorts of things under their skirts—guns, information—without fear of being searched.

Dresses required very tightly laced corsets and either crinolines, hooped petticoats, or steel-cage petticoats.[h] Even pregnant women wore corsets. Women also wore various other undergarments—corset covers, stockings, false ruffled leggings, and open drawers. Around 1870 women abandoned the full skirt for one which was cut very close or elaborately draped in front. In the back it remained full to fit over a bustle.

Most of the time, fashionable nineteenth-century women were covered from neck to toe. Evening dress at various points would feature a low neck; some day dresses were ankle length. The clothing was not only constricting, it was heavy. In the 1860s

[f]Sleeves tightly fitted below the elbow and quite puffy above the elbow. So named because of their resemblence to the triangular shape of a leg of lamb.

[g]Stiffened petticoats made of a combination of horsehair and wool.

[h]Petticoats with steel hoops from about the knees down. They permitted women to dispense with the heavy layers of petticoats.

some dresses required ten yards of crinolines.

Poorer women wore similar dresses made of coarser fabrics, and they used fewer crinolines. Nineteenth-century women factory workers wore full skirts even though they occasionally tangled in machinery or caught fire. Women found it difficult to board streetcars or pass on the streets. Dresses swept the ground and quickly became covered with mud and muck. Women finally gave up full skirts in favor of tightly corseted and bustled costumes in the late nineteenth century. The new style was a reduction in bulk—women could at least pass one another on the street with less difficulty. However, the skirts were so tight they impeded walking.

It was assumed that women's clothing need not allow for much physical exertion. The most ordinary activity—walking, sitting, even breathing—was restricted. Not even sports clothing permitted much freedom of movement. Riding habits were multilayered and complete with bustles (women rode sidesaddle) and bathing suits included long tunics, bloomers, stockings, and hats.

At several points in the nineteenth century, the medical profession and dress reformers campaigned hard against tight lacing. They blamed the tightly laced corsets for a variety of physical maladies or complaints: curvature of the spine, shortness of breath, fainting, and displacement of the uterus. Such restrictive clothing provided ample reasons for dress reform. Amelia Bloomer's midcentury version of sensible dress for women featured full oriental trousers topped by a tunic or smock. The pants, dubbed bloomers, were not very popular. Women persisted in wearing skirts even when the bicycle craze hit in the 1890s.

The end of the century brought the most extreme form of corset. It was originally designed as a "health" corset that would not exert extreme pressure on waist and diaphragm. However, fashionable women simply laced it tighter over their ample curves. The effect was an S shape—the Gibson Girl look of bust forward, waist tightly laced and buttocks back. Its wearer looked perpetually tipped forward. Women wore enormous plumed, beribboned or flowered hats to balance the trailing derriere. Women of all classes adopted the style. The amount of decorative detail and the type of fabric signaled the wearer's wealth. Working women wore plain shirtwaists modeled on the

man's shirt. Wealthy women wore elaborately tucked, pleated, laced, and beribboned versions.

At this point fashion began to penalize the woman with an ample figure. Shortly before World War I, fashions requiring strict corseting lost popularity, replaced by dresses emphasizing a "natural figure." Women still wore corsets, some of which reached to the knees, but the fashionable profile was straight or tailored. Skirts remained long and for a brief period were very tight at the ankles.

By the time the First World War began, everything women wore could be purchased ready-made. Wealthy women and those of the growing middle class wore the same kinds of clothes, purchased at large department stores or by mail order. Department stores and mail-order houses dated from the mid-nineteenth century. By the early twentieth century department stores featured huge inventories of inexpensive clothes in often

Dress, 1835-37 (a); bloomer costume, 1851 (b); dress with bustle, 1887 (c); bathing costume, 1896 (d); Gibson shirtwaist, 1895 (e). These illustrations show some of the complexity and bulk of middle- and upper-class women's costuming over the course of the nineteenth century. Even at-home dresses or sporting costumes might feature tight corseting, many layers of petticoats, or bustles. The bustle reached its most extreme form in the 1880s and 1890s. B, D, E, reprinted with permission of CHARLES SCRIBNER'S SONS, an imprint of MACMILLAN PUBLISHING from Five Centuries of American Costume, by R. Turner Wilcox. Copyright ©1963 R. Turner Wilcox. A, C, reprinted with permission of NEW AMSTERDAM BOOKS (US) and THE HERBERT PRESS LTD (UK) from Fashion in Costume, 1200-1980, by Joan Nunn. Copyright ©1964 Joan Nunn.

Crinoline, 1857 (a); corset and cage crinoline, 1866 (b); horsehair bustle and petticoat, 1870s (c). Illustrated on p. 54 are some undergarments nineteenth-century women wore beneath their voluminous clothes. Crinolines were often extremely heavy and the cage construction was intended to reduce the weight. All are European examples, but American women also wore them. Reprinted with permission of NEW AMSTERDAM BOOKS (US) and THE HERBERT PRESS LTD (UK) from Fashion in Costume, 1200-1980, by Joan Nunn. Copyright ©1964 Joan Nunn. (OVERLEAF)

a

b

d

e

c

a

b

c

palatial surroundings. Women out of reach of the stores ordered by mail from Sears Roebuck or Montgomery Ward. Between 1894 and 1921 the Sears catalog tripled in length to 1,064 pages and went from no illustrations of women's clothing to ninety pages of it.

Few mid-nineteenth century women looked beyond home and family. Sixty years later millions of women were in the workforce and thousands were in college. Women were actively engaged in a variety of political, civic, and reform activities. The confining dress of the nineteenth century was not appropriate for their more active lives.

Skirts were not nearly so narrow by the 1920s, but they were a lot shorter, close to knee length at least for day wear. Sports clothes—shorts, slacks, short skirts—appeared in the 1940s, and women factory workers often wore slacks. The obsession with the tiny waist reappeared after World War II with Dior's New Look of large bust, cinched waist, and full, though shorter, skirt. By the end of the 1960s, the girdles which had been the last word in comfort earlier in the century were disposed of. Panty hose were in, heels were shorter, and women had discovered jeans. By the 1980s, a whole range of clothing was "suitable."

What women wear is still in large part determined by what they do, but their areas of activity are much wider. Women are no longer expected to confine themselves to a purely domestic role. They are teachers, lawyers, doctors, students, assembly-line workers, secretaries, forklift operators, construction workers, and astronauts. They swim, golf, ride horseback, and work for a variety of causes, all in addition to caring for their families. They choose their clothing to match their activity. There is no longer a female uniform which signals lesser status.

Women's suit, 1912 (a); coat and skirt, 1929 (b); Dior New Look, 1947 (c). Note the change from the tight bodice and waist of the late nineteenth century (p. 53) to a straight silhouette in the early twentieth, and then the emphasis on the hourglass figure after World War II (p. 56). A, C, reprinted with permission of NEW AMSTERDAM BOOKS (US) and THE HERBERT PRESS LTD (UK) from Fashion in Costume, 1200-1980, *by Joan Nunn. Copyright ©1964 Joan Nunn. B, reprinted with permission of CHARLES SCRIBNER'S SONS, an imprint of MAC-MILLAN PUBLISHING from* Five Centuries of American Costume, *by R. Turner Wilcox. Copyright ©1963 R. Turner Wilcox. (OVERLEAF)*

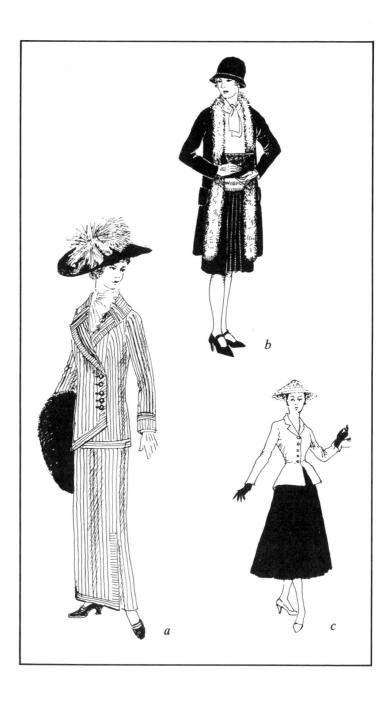

b

a

c

CHAPTER THREE

Reformers and Crusaders

After the Civil War, New Jersey entered a period of rapid population expansion, economic growth, and political change.

From 1870 to 1920, the state's population more than tripled, increasing from around 906,000 to about 3,156,000. It grew by about 29.4 percent each decade, and almost 2,250,000 in fifty years. In 1900 New Jersey ranked sixth in population among the forty-five states and third nationally in population density.

Immigration, natural population growth, and the migration of African-Americans from the South all contributed to the state's population surge. Most of the immigrants came from Italy, Germany, Poland, and Ireland. In 1880 about one in five New Jerseyans were foreign-born. By 1910 more than one in four were foreign-born. Immigrants and native-born alike flocked to the industrial cities of Newark, Jersey City, Paterson, Camden, and Trenton looking for work. By 1880 each of these cities had a population of over thirty thousand. As early as 1880, more than half of New Jersey's residents were city dwellers.

Employment opportunities attracted many African-Americans from the South. Migration was heaviest during World War I as a result of the demand for factory workers in the cities and domestic servants in the suburbs. There were about thirty-one thousand African-Americans in New Jersey in 1870 and 117,000 in 1920. This represents close to a fourfold increase in numbers, and an increase in the black percentage of the population from 3 to 8 percent.

Most settled in the northern part of the state in cities like

Newark. Blacks occupied the bottom rung of the occupational ladder. Black men worked as unskilled laborers, deliverymen, janitors, and teamsters. Black women found that the only jobs open to them were as laundresses, cooks, and maids. Blacks did not begin to win factory jobs until World War I, when the need to supply the armed forces increased the size of the workforce. Even then they were relegated to the least desirable and lowest-paid work.

The state's economic expansion meant many new jobs. Factories of all kinds, commercial laundries, and textile mills all hired many female employees. Improvements in technology introduced new products to the consumer market and appliances for the home; many women found work making these products. Growing numbers of women also moved into what we now call white-collar jobs as retail clerks, secretaries, typists, bookkeepers, nurses, teachers, and librarians. By 1910 women made up 25 percent of the state's labor force.[a]

By the early twentieth century, women were also doing most of the buying for their families. Ready-to-wear clothes, household appliances like refrigerators, prepared foods, and department stores and household appliances began to transform the daily lives of tens of thousands of New Jersey women. Electric irons were available for purchase in 1904; W. H. Hoover manufactured his first electric vacuum cleaner in 1908; gas cookers were commercially available by 1914; and electric refrigerators appeared on the market in 1913. Their use spread rapidly after World War I.

Equal Rights for All

Although the women's rights movement had been launched at the Seneca Falls Convention in 1848, it gained little momentum before the Civil War. Once the war was over and the slaves were freed, reformers turned to causes other than abolition, including woman suffrage.

For several years, New Jersey alone among the free states

[a]The labor force includes all persons over fourteen years old, employed or unemployed but willing and able to work.

failed to ratify the Thirteenth Amendment that outlawed slavery. The state's recalcitrance gave reformers the opportunity to attack the universal white male suffrage provision in the 1844 constitution. They sought universal suffrage, meaning equal voting rights for black males and all women. Proponents of universal suffrage formed the American Equal Rights Association (AERA) in 1866, establishing chapters in New Jersey, Pennsylvania, Missouri, Ohio, Iowa, and the District of Columbia.

Abolitionists Lucy Stone and her husband Henry Blackwell were leading AERA activists in New Jersey. Their marriage in 1853 caused a social stir when they publicly announced complete equality in their marital arrangement, including finances, and Stone's retention of her birth name. Stone, who was originally from Massachusetts, was an abolitionist speaker for the Anti-Slavery Society and frequently spoke out about the status of women while lecturing about the evils of slavery.

Stone had her first clash with New Jersey authorities in 1858, when she returned her tax bill to the tax collector of Orange with a notice that she would not pay her real estate taxes until granted the right to vote. She wrote, "for years some women have been paying their taxes under protest, but still taxes are imposed, and representation is not granted."[1] Lucy Stone did pay the consequences. Her possessions were seized and sold at auction. Fortunately, the items were purchased by a neighbor who returned them to her.

Under the auspices of the AERA, Stone and Blackwell held a number of conventions in New Jersey in 1867 on behalf of women's rights and black suffrage. They often met with a hostile reception; for example, the gathering at Princeton University was marred by the hostility of many students from the South. Stone also appeared before a committee of the legislature to request the removal of the phrase "white male" from the state constitution. The request was necessary because the newly passed Fourteenth Amendment to the federal Constitution did not enfranchise blacks, but only guaranteed them equal protection under their state's laws.

At her legislative appearance, Stone reviewed the early history of suffrage in New Jersey and noted that women were not the only group charged with fraudulent voting in the 1807 election. White males, she added, voted regardless of property

or education while all women were without representation. She petitioned the legislature to correct this miscarriage of justice and to enfranchise all women and black men. Despite her plea, the proposal was defeated by a vote of thirty-two to twenty-three.

In November 1867, the New Jersey Woman Suffrage Association (NJWSA) was founded, and Lucy Stone became its first president. Its goal was to hold a referendum to restore for women in New Jersey the right to vote. (Such a referendum would not take place until 1915.) In the meantime, suffrage activity through the NJWSA went forward with the formation of suffrage societies in several communities, including Camden, Morristown, New Brunswick, Passaic, Paterson, Rahway, and Vineland.

In 1868 the Vineland society, headed by John Gage, made an attempt to have women vote in that year's presidential election, and this resulted in one of the first woman suffrage demonstrations in the United States. On election day, the women who entered the polling place at Union Hall tried to cast their ballots with the men, but were refused. Instead, they were directed to a table with a separate voting box, formerly used for the crating of grapes. Husbands and wives who came to the polls together were forced to vote separately. After leaving the polling place some women escorted others to the polling place or baby-sat for their children. The election returns showed that 172 women voted (including four blacks). Of these, 164 voted for Republican party candidate Ulysses S. Grant and two voted for Elizabeth Cady Stanton, founder of the women's rights movement. While the women's votes did not count, they indicated the number of women in the community interested in such political participation.

In the same election, Lucy Stone and her mother-in-law Hannah Blackwell, both property holders and taxpayers in Roseville (then a part of Newark), attempted to vote by insisting upon their suffrage rights according to the 1776 state constitution. Although the effort failed, it suggested a strategy for the future. New Jersey women should request from the legislature the restoration of a political right that had once been granted and then taken away. Suffragists from no other state could argue from that historical perspective. If the legislature could take the vote away from women, it could give it back.

For the next several decades, state suffragists filed petition after petition with the legislature for full voting rights. The petitioners requested that the word "male" be struck from the state constitution, but they received either a negative response or only a courteous hearing. In 1875 New Jersey ratified the Fifteenth Amendment, which enfranchised blacks, and the legislature removed the word "white" from the state constitution's suffrage provision. Suffragists then argued for the vote on the basis of justice.

They reasoned that if voters could no longer be excluded because of race, it was only fair and just that they could not be excluded on the basis of gender. Some suffragists adopted a second argument that was based on the cultural conception of women as virtuous guardians of morality. Extending suffrage to women would improve public morality.

During this time women achieved some small political gains. The rights of married women were expanded and clarified by the state legislature. In 1871 women received equal rights to custody of children in a divorce. In 1874 New Jersey granted married women the right to their personal property and inheritance. By the 1890s New Jersey women could make contracts, sue and be sued, and control their earnings and wages as separate property. In 1873, a bill was passed making New Jersey women eligible to run for the office of school trustee. Fourteen years later another law granted women in townships and villages (but not cities) the right to vote at school meetings. By 1890 nineteen other states had granted women some degree of participation in matters of education. In 1894, however, the New Jersey Supreme Court ruled that the school suffrage law of 1887 was unconstitutional. Women, explained the state attorney general, had the right to vote for school appropriations but not for trustees. Curiously, they could not vote for trustees but they could hold the office themselves, and fifty women did between 1873 and 1895.

The New Jersey Woman Suffrage Association reacted to the 1894 ruling by forming a committee on school suffrage. The association had two goals: first, to secure a constitutional amendment to give women full school suffrage in cities, villages, and townships; and second, to encourage women to continue to participate at school meetings on appropriations. A proposed amendment to give women full school suffrage was defeated

by about ten thousand votes. A negative vote in the cities, where female participation had not been tested, contributed substantially to the measure's defeat. In addition, some voters assumed that the measure gave suffrage to women in all cases. In 1895, both houses of the state legislature approved a proposed constitutional amendment to give women the right to vote in school elections, but the measure was defeated in a referendum held in 1897. For the next decade or so, the suffrage association continued its efforts for women's rights but made no gains.

On the Picket Line

By the end of the nineteenth century, New Jersey's economy looked very different than it had in 1800. Most of the state's workers no longer toiled on farms. They worked in mills and factories or labored to bring the products of those industries to market. An extensive railway system brought raw materials to the state's industries for manufacture into finished products and carried those products to market out of the state.

A generation before, most women workers found employment either as domestics or as dressmakers, seamstresses, or milliners. By the 1880s many could be found in New Jersey's textile industry: silk in Paterson, and cotton and wool in Passaic. Women's work, at least for pay, had changed a great deal.

Work in the textile industry was accompanied by a constant struggle over wages, hours, and working conditions. The national economic depression in 1873, for example, meant lower orders for the mills and wage cutbacks for the workers. In late 1874 women workers in the mills of Paterson, Passaic, and New Brunswick struck over wage cutbacks. The strike went on for several weeks, but the mill owners refused to yield. The workers returned to the mills, afraid to risk the loss of their jobs.

Paterson was a major industrial city in the 1870s. It had become the leading silk manufacturing center for three reasons: It had power from the city's waterfalls; it enjoyed nearby port facilities and proximity to the garment center in New York; and it had other growing industries—railroads, iron, and machinery—that helped attract a ready supply of workers. These workers, primarily Irish, German, and Italian, flocked to Paterson for employment—men to heavy industry, and women and children to the textile mills.

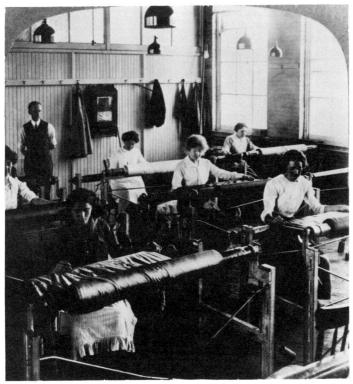

Picking the cloth. *These women silk workers are shown here searching rolls of silk for flaws. They are watched by a male supervisor. Courtesy PATERSON MUSEUM.*

By 1890, Paterson, known as the "Lyons of America" for its silk manufacturing, had a population of 123,000; one-third of its workers, mostly of the "new immigration," were employed at the textile mills. In 1910, nearly half of the city's women worked in some aspect of the industry—weaving, warp making, and cloth picking. Most female silk workers were single and worked from age fourteen (state legal minimum age) until they married (usually in their early twenties). They contributed all or part of their income to the support of their families.

The silk industry paid the lowest wages of the state's twenty-

five leading industries, and women earned lower wages than
men. In 1912 there were two brief and unsuccessful strikes by
the silk workers. Most of the workers involved were Italian and
Jewish immigrant women. They struck against the ten-hour work
day, unhealthy working conditions, and low and variable weekly
wages. They also opposed the new four-loom weaving system.
Replacing the two-loom system threatened to reduce the
number of employees and to increase the rate of production
without increasing wages.

On January 27, 1913, the 800 men and women of the Henry
Doherty Silk Company quit over the firing of four members
of an employee committee negotiating about the multiple-loom
system. The walkout resulted in a general strike in the silk
industry, affecting approximately twenty-two thousand workers
for twenty-two weeks. The workers joined the International
Workers of the World (IWW) Local 152, which had begun
trying to organize the industry in 1907. They demanded an eight-
hour day, a minimum wage of $12 a week, recognition of IWW
representation, and elimination of the four-loom system.
Management rejected all the demands. Beatings, clubbings,
court orders, and an estimated 2,200 arrests and 300 convictions
combined to make the Paterson strike one of the most violent
and notorious in labor history.

Women joined the union, and participated in all strike-related
activities including picketing and fundraising. Some women were
strikebreakers, either because their families were antiunion or
their finances were too precarious. The famous union organizer
Elizabeth Gurley Flynn held special meetings for women
strikers to encourage union solidarity.

One woman striker who stood out for her steadfastness and
courage was seventeen-year-old Hannah Silverman. A picket
captain of her silk mill, she was called the "greatest little IWW
women in America" by union leader Bill Haywood.[2] Silverman
was arrested and charged with unlawful assembly; she returned
to the picket line only to be arrested twice more. Although she
was sentenced to sixty days in the county jail, she did not serve.
Known as the "Joan of Arc of the Silk Strikers," Silverman also
headed a parade to Madison Square Garden in New York City
for the "Pageant of the Paterson Strike" on June 7. The
pageant, planned by the Harvard-educated socialist John Reed
to bolster the depleted strike fund, portrayed scenes from the

streets of Paterson with the men and women playing themselves. Although the event drew an audience of over fifteen thousand it raised only $1,996 after expenses.

The solidarity of the workers was finally broken, and the five-month strike failed. The impoverished silk workers gradually returned to work under shop-by-shop settlements dictated by the companies. Many lost their jobs to strikebreakers. Those who returned came back to the same conditions that had provoked the strike. According to labor historian Philip S. Foner, even though the union had won some important victories, as in the textile strike at Lawrence, Massachusetts, "the IWW suffered a setback in Paterson from which it never completely recovered."[3] On the positive side, another historian, Delight W. Dodyk, claims that although women never rose to leadership in union activity they contributed in "the day to day progress of the protest" and "challenged the accepted notion of acceptable behavior of female workers." Moreover, "women silk workers had displayed a new level of cooperation with men and of activism on their own behalf which stood as a sign to women in the industry."[4]

Women's Clubs

In the late nineteenth century both white and black women invested considerable energy in clubs of all types.

The church had been the most important institution for blacks. Religion, whether in church or at camp meeting, had provided a focus for social interaction throughout the nineteenth century. Social clubs provided a new outlet, and black women joined political, civic, literary, religious, and sororal organizations in great numbers. Sons and Daughters of Africa, Queen Esther Court, Eastern Star, and Household of Ruth provided a context for social activities, good works, and education programs. Some clubs even offered medical benefits to their members. Black women and men interested in working for civil rights formed chapters of the NAACP and the Urban League. Orange and Newark started their chapters of the NAACP in 1913 and 1914, and Newark began its Urban League chapter in 1919. In 1915 black women's social clubs united as the New Jersey State Federation of Colored Women's Clubs, under the direction of Florence Spearing Randolph. Education

Queen Esther Court, No. 1, Atlantic City, ca. 1900. Clubs offered black women opportunities for socializing as well as a venue to organize benevolent activities. *NEW JERSEY HISTORICAL COMMISSION.*

remained a major concern for the black community, and black women, through the federation, provided scholarships for black high school students.

Middle-class white women, though better educated than women of previous generations and blessed with more leisure time, still had few career paths other than teaching, nursing, or social work. Literary, social, philanthropic and other clubs provided outlets for their energies.

Sorosis, founded in 1868 by "Jennie June" Croly, was the "Mother of Clubs." It was the first all-female social and intellectual club, exclusive of religion and politics, and met regularly at Delmonico's restaurant in New York City. It drew women from New Jersey such as the Reverend Phebe A. Hanaford of the First Universalist Church in Jersey City and Erminnie A. Smith, the first woman elected to the American Academy of Science. Sorosis members founded other clubs which attracted other women to organizations devoted to education, art, music, literature, history, home life, philanthropy, science, and business.

The first women's club in New Jersey and the fifth in the country was the Women's Club of Orange, established in 1872. Other New Jersey clubs that followed included the Quiet Hour Club (Metuchen), Half-Hour Reading Club (Merchantville), Over the Teacups (Elizabeth), Current Topics Club (Newark), Travellers' Club (Roseville), Odd Volumes (Jersey City), and Athena (Bayonne). They promoted community projects such as kindergartens and libraries and avoided controversial issues.

The concept of women's clubs grew popular nationwide, and in 1890 Sorosis invited ninety-seven clubs to establish the General Federation of Women's Clubs (GFWC), a national organization incorporated in New Jersey three years later. Its first president was Charlotte Emerson Brown of Orange. The following year the Women's Club of Orange issued a "call" to the women's clubs of New Jersey to unite as the State Federation of Women's Clubs (SFWC). Margaret Tufts Swan Yardley of Orange served as first president of the organization, which had a charter membership of thirty-six clubs. By 1913, the SFWC included 132 clubs and approximately thirteen thousand members. To avoid dividing its members, the SFWC did not endorse suffrage until 1917.

The branches of the state federation worked for municipal improvements such as parks, playgrounds, day nurseries, and housing. On the state level, the organization concentrated on two substantial projects, the preservation of the Palisades and the establishment of a public college for women (discussed below).

In March 1896, it launched a campaign to save the Hudson River Palisades from destruction by commercial interests and preserve them as a scenic and recreational area. President Yardley led a demonstration by 300 women to the state legislature in Trenton to protest against quarry lobbyists. In 1899, two federation women were appointed by Governor Foster M. Voorhees to a commission on the future of the Palisades. Because of the organization's lobbying efforts, the area was preserved for the development of Palisades Interstate Park in 1906.

By the 1890s, many women's clubs were deeply involved in campaigns for urban reform. Settlement-house workers like Cornelia Bradford in Jersey City deplored the airless tenements, overcrowding, poor sanitation, and disease associated with the

state's rapid urban-industrial growth. Bradford and her fellow "social housekeepers" were determined to clean up society.

In a national context the urban reformers' complaints about municipal corruption and the unregulated power of local businessmen became progressivism's attacks on concentrated wealth, big business, and governmental corruption. Progressives saw all these things as threats to democracy and demanded that government reform itself as well as curb the power of wealth and big business through regulation. Progressives set much of the political agenda until the beginning of the First World War. Workmen's compensation, child-labor laws, trust-busting, public-health laws, the regulation of collective bargaining, the recall, and direct election of senators were all features of the Progressives' campaign to reform society. In New Jersey, Governor Woodrow Wilson pushed through a Corrupt Practices Act, a Public Utilities Law, and a Workmen's Compensation Act among other reforms.

Women Progressives worked hard for temperance, child welfare, decent housing, an end to municipal corruption, and the other reforms they thought society needed, but few strove for sexual equality. Even the struggle for the vote was less a fight for sexual equality than a campaign to give women the ballot so that they might have the power to improve society.

Education for Women

The SFWC also backed the efforts of Mabel Smith Douglass, president of the College Club of Jersey City, to advance higher education for women. Wisconsin, Michigan, Missouri, Iowa, Kansas, Indiana, Minnesota, and California had established coeducational state universities by 1870, but there was no public college for women in New Jersey. Rutgers officials refused to make the school coeducational, and women were not admitted to the private institutions of Princeton University, Drew Theological Seminary, or Princeton Theological Seminary. Evelyn College, the first and only private nonsectarian women's college in the state, had been founded in 1887 by Joshua Hall McIlvaine, a Presbyterian minister and professor at Princeton, but it lasted only a few years. The College of St. Elizabeth, founded in 1899, was a private Catholic women's college.

The founding of a public college for women in New Jersey

grew naturally out of a campaign to provide equal education. In 1864 Rutgers had been selected as a land-grant college under the federal Morrill Act. The act provided free federal land to colleges providing training in agriculture, technical skills, and home economics. Naturally, there was some expectation that Rutgers would provide educational opportunities for women, and by 1918 there was growing pressure from women's groups to fulfill the expectation. Mabel Douglass was prominent in the campaign to persuade the Rutgers' trustees to establish a separate women's college. A biographer of Douglass described the campaign as a "by-product of the larger movement for women's rights."[5] Prominent among the forces that created it was the New Jersey Federation of Women's Clubs.

In May 1918, the trustees voted to establish the New Jersey College for Women and invited Douglass to become its first dean. They made a rather odd choice. Douglass had no degree beyond a BA and her only teaching experience had been a three-year stint in New York City many years before. Nevertheless she accepted and remained as dean until her resignation in 1932.

Whatever the board of trustees had had in mind, Douglass had her own ideas. She chose the faculty and devised the curriculum herself. Men were paid considerably more than women. Douglass placed great importance on appearance and insisted that students and women faculty alike look feminine. The curriculum in the college's early years included liberal arts and vocational courses so that its graduates would be properly prepared to be teachers, secretaries, and efficient homemakers. In 1955 the college was renamed for her.

Reformers of the time also joined with the state's government and business leaders to revamp the state's educational policy. Industrialization, urbanization, and the growing population increased the pressure for a broad-based educational program.

In 1871, the legislature approved a statewide system of free public education, one of the last northern states to do so. However, it took several decades for the state's educational program to meet the need for more classrooms, reform of the high school curriculum, special education, vocational education, compensatory education enforcement, and especially teacher training.

New Jersey, like several other states, had more female teach-

ers than male. As much as any other occupation, teaching demonstrated the professionalization of what had once been a domestic role—the instruction of the young—as well as the feminization of what had been a male profession. Women teachers were generally young, single, and paid one-half or less the salaries of men in the profession. State Superintendent of Public Instructon Ellis Apgar noted approvingly in his 1870 report,

> the time is not far distant when we must depend almost entirely upon female teachers to educate our children. Nor is this fact to be deplored. . . . I have always found that those schools which are under the exclusive charge of females compare favorably, both in discipline and scholarship, with those taught by male teachers. The willingness of women to work for low wages has, undoubtedly, induced trustees to engage them more exclusively for that sum ($400–600/yr) a first class female can usually be employed, but a male teacher who has no higher ambition than to teach for such wages is not likely to be rated better than second or third class.[6]

The eagerness of school districts to employ women had its limits. Most places required teachers who married to resign. Teaching was an appropriate profession for women, but married women were expected to concentrate on home and family.

New Jersey had long relied on colleges and universities in nearby states to supply its classroom teachers. The New Jersey Normal School at Trenton, a coeducational institution founded in 1855, was the state's only teacher-training school. Several cities like Paterson and Newark founded their own teacher institutes or Saturday normal schools. A teacher shortage in 1900 prompted the passage of the School Act of 1903 to establish additional teacher-training schools, and normal schools were founded in Montclair (1908) and Newark (1913). While the educational opportunities for women in the state gradually improved, the disparity in salaries for men and women professionals continued. As women began to dominate professions like teaching, the status of the professions declined. Low pay and low status marked the feminized professions. Most people assumed that the educated women who entered teaching, nursing, medicine, and law, would leave when they got married. Indeed, in many places, women who married had no

choice. They lost their jobs. Women did not have careers as nurses or lawyers, but temporary professions to be abandoned for "real" careers as homemakers.

Charity and Social Work

The Progressive Era, which lasted until World War I, also produced an array of philanthropic and charitable organizations in the state which relied heavily on the initiative and leadership of women. Emily Williamson of Elizabeth was a founder and secretary of the board of the State Charities Aid Association, which examined state-run charity homes and their care of dependent children. The association financed the administration and subsidization of foster homes.

Caroline B. Alexander (later Wittpenn) of Hoboken, was involved in numerous philanthropic causes, and championed the cause of prison reform in the state, especially the treatment of women in reformatories. Her leadership resulted in the establishment of the State Reformatory for Women at Clinton Farms in 1912, to house and supervise women separately from men. The goal was the rehabilitation and training of women, rather than the reform of criminals. Wittpenn later became president of the board of managers of the State Reformatory for Women of New Jersey.

The Newark Female Charitable Society, founded in 1803 to "relieve immediate suffering, and to find employment for the idle," flourished during the Progressive Era.[7] In the 1880s, a building was rented and teachers hired to help the disadvantaged become more self-sufficient. The society raised money to train women and children in sewing and in laundry and kitchen work and to pay them for their efforts. The Fresh Air Fund Committee raised money to send children to the country during the summer. The Crazy Jane Society became an auxiliary to the Charitable Society in 1874, and through it wealthy women in Newark provided poor women with both clothing and employment in sewing.

Another popular vehicle for educated middle-class women was the settlement-house movement. Emulating Jane Addams, who founded Hull House in Chicago, Cornelia Bradford founded the first settlement in New Jersey, Whittier House, in

Jersey City in 1893. In so doing, she launched a veritable crusade in social reform work in the state.

Social reformers established their settlement houses in poor urban areas among the people they were trying to serve. They hoped that the clinics, workshops, and recreational facilities would improve the lives of the impoverished immigrant population. Settlement-house workers were intent on making it easier for immigrants to assimilate and become more "American," and they also hoped to combat political radicalism. Cornelia Bradford, like Jane Addams, visited Toynbee Hall in England, the prototype for settlements in the United States. She later worked at Hull House, and then decided to start her own settlement in Jersey City. She called her settlement Whittier House after the poet John Greenleaf Whittier. In time, the settlement boasted Jersey City's first kindergarten, its only playground, a free dental clinic, a mothers' club, evening study clubs for factory women, numerous other clubs and classes, and even a pawn shop.

Bradford also supported the work of Mary B. Sayles, a Whittier resident working on a fellowship from the College Settlements Association. Sayles completed a survey on Jersey City housing conditions, which was published in the *Annals of the American Academy of Political and Social Science* in 1903. The survey reported on substandard housing conditions such as severe overcrowding, lack of street, hallway, and house lighting, and general deterioration of homes. The difficulties Sayles experienced in collecting the data from reluctant or absent tenants, landlords, and homeowners resulted in the appointment of a state tenant-house commission, eventual passage of a statewide tenement code, and the formation of a neighborhood council in Jersey City. In addition, Bradford and her assistants went to Paterson and other communities to make similar studies.

Whittier House became the founding center for other state and local organizations such as the Legal Aid Society, the New Jersey State Consumers' League, the Jersey City Society for the Prevention of Cruelty to Children, the Hudson County Tuberculosis League, and the North American Civic League (which eventually became the State Bureau of Immigration). Bradford also was responsible for the formation in 1903 of the New Jersey Association of Neighborhood Workers, a statewide organization

for settlement houses to lobby for social legislation. She became
president of the New Jersey conference for social work. Her
reformist spirit included lobbying in Trenton for the ten-hour
work day, and the establishment of juvenile courts, parental
homes, and county penitentiaries. She also advocated woman
suffrage, hoping that giving the ballot to women would produce
speedier legislation for social reform.

Women temperance advocates, hoping to resume their cam-
paign against alcohol begun during the pre–Civil War period,
founded the Women's Christian Temperance Union (WCTU)
in 1874. WCTU members believed that the prohibition of al-
cohol would improve society and secure the tranquility of home
life. The work of the WCTU began in New Jersey in the 1880s.
Temperance advocates in the state tried unsuccessfully to outlaw
liquor traffic and to move the legislature to set aside funds for
an educational program about alcohol in the public schools. In
an address in 1890, Sarah J. Corson Downs, president of the
state organization, scolded the legislature for not taking action
against the sale of alcohol:

> This foe stands upon the threshold of every home in New Jersey,
> and is the inspiration of every crime which disgraces our civ-
> ilization. . . . The law of this state is license, and license means
> drunkenness, pauperism and crime.

For Downs, women needed to secure the vote so they in turn
could effect reforms like temperance. She viewed suffrage as
"the surest method of overthrowing the liquor traffic and all
the sins against our homes."[8]

However, not all suffragists supported temperance, and not
all temperance advocates supported suffrage. The national or-
ganization endorsed suffrage in 1883 and introduced its
members to the campaign for women's rights through the or-
ganization's franchise committee. In New Jersey, however, it
took WCTU leader Theresa Walling Seabrook of Keyport ten
years to establish a franchise committee in the state organiza-
tion. Temperance work alone did not transform women into
either suffragists or feminists. It did, however, introduce many
women to a social reform environment which broached the issue
of women's rights.

Suffrage Campaign

By 1912, women had the vote in nine western states of the Union. In January of that year, a resolution for a suffrage amendment to the New Jersey constitution was introduced in Trenton by a suffrage coalition called the Joint Legislative Committee. The committee was formed the previous year and included the state's four suffrage organizations: the New Jersey Women's Suffrage Association, the Women's Political Union, the Equal Franchise Society, and the Men's League for Equal Suffrage. Although the resolution was defeated, it later passed the legislature and was submitted to the voters in a referendum in 1915.

Opposition to the referendum surfaced quickly. In 1915, the New Jersey Association Opposed to Women Suffrage counted eighteen thousand members. The Men's Anti-Suffrage League of New Jersey circulated a pamphlet, "The Woman Suffrage Crisis in New Jersey," which asserted that giving women the vote would jeopardize the American tradition of home and family, and that the sexual division of labor had served civilization well and should not be altered by suffrage for women.

In response, suffragists argued that denying the ballot to women simply because they were women was undemocratic. Women who paid taxes in the state were denied the vote while all men, regardless of education, criminal record, mental condition, or class, were entitled to vote. Suffragists also held that the vote would be an agent of progressive reform. Given the ballot, women would use their votes to improve the welfare of society.

Antisuffragists charged that suffrage would result in reforms such as prohibition, closing down the lucrative state liquor industry and its related businesses. Suffrage would encourage socialism, trade unionism, and even endanger traditional family life and marriage.

The propaganda of the antisuffragists was couched in the rhetoric of "separate spheres." Women ruled at home and did not need to extend their influence to either politics or business. The "antis" debunked the suffragists' reform argument about improving public morality by reciting cases of corruption in Nevada, Colorado, and Utah, all states where women had the vote. Finally, they charged, only one-fifth of the women of the

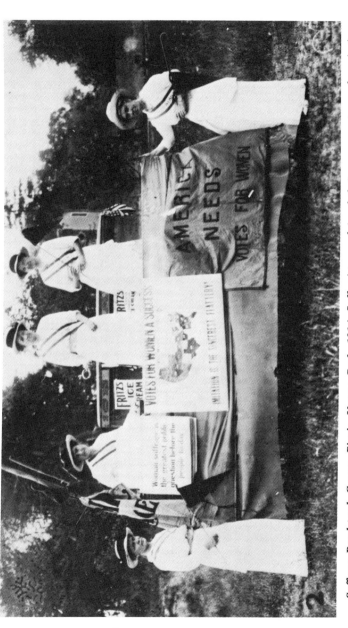

Suffrage Bandstand, Grange Picnic, Verona Park, 1914. *Suffragists proclaimed their message at parades, picnics, rallies—anywhere people gathered. Courtesy NEWARK PUBLIC LIBRARY.*

state wanted suffrage, as demonstrated by the membership in the state suffrage societies. Governor James F. Fielder, a Democrat, reinforced the view by commenting: "I am very much opposed to imposing on women a responsibility which I feel certain a majority of the women in the State do not seek."9

On October 19, 1915, in an all-male election, the antis defeated the amendment by a vote of 184,400 to 133,300, capturing every county except Ocean. President Woodrow Wilson, who still voted in New Jersey, announced his support of the amendment two weeks before the election. He traveled to his voting district in Princeton Borough to cast his ballot, demonstrating his confidence in the state-by-state approach to suffrage for women. The amendment had the support of state Progressives, liberals and antiliquor interests such as the Anti-Saloon League and the WCTU.

However, it was endorsed by neither the New Jersey Federation of Labor nor the Federation of Women's Clubs. It faced strong opposition by the liquor lobby. Moreover, many men were alarmed at the prospect of the women's vote affecting political, business, or labor conditions.

With the state suffrage issue defeated at the polls, suffragists in New Jersey directed their attention to the national campaign for a federal amendment. Membership in the New Jersey Women's Suffrage Association grew to over fifty thousand people in 215 chapters. In September 1916, the national organization held its convention in Atlantic City, and its president, Carrie Chapman Catt, formally inaugurated her "Winning Plan," a middle-of-the-road proposal to rally the support of Congress for the amendment. Women would continue to work on the state level in preparation for the eventual campaign to ratify a federal amendment.

Catt invited President Wilson to the Atlantic City convention to gain his public endorsement of a federal suffrage amendment. Wilson had been reluctant to move from his states' rights stand on the issue and had even been counted among the antis when he was governor of New Jersey. Catt hoped that the long-term struggle of American women, coupled with the political overtones of suffrage as a measure of liberal reform, would change his opinion.

As it turned out, Wilson attended the convention on September 8, 1916, as part of his presidential reelection cam-

paign. He remained throughout the day's program, and was its concluding speaker. In his speech, he recognized the women's movement as having traveled a "long and arduous path" and called it "one of the most astonishing tides in modern history."[10] From the omission of his usual rhetoric on state sovereignty, the suffragists knew he had endorsed a federal suffrage amendment, even if he did not make an explicit commitment to the cause.

One strong advocate of a federal suffrage amendment was Alice Paul from Moorestown. In 1916 she broke with the suffrage association to form an independent and more militant suffrage organization, the National Woman's Party (NWP). Raised in a liberal Quaker tradition and imbued with the principle of equality for all, Alice Paul was a 1905 graduate of Swarthmore College. She began her social activism as a resident worker at the New York College Settlement and the Christian Social Union Settlement in London. While in Great Britain for graduate studies, she became involved in the British suffrage movement, which was notably more militant than its American counterpart. She both participated in the movement's activities—parades and demonstrations—and experienced the government's response—imprisonment and forced feedings.

Paul had entered the American suffrage campaign in 1912, after completing her doctoral degree in social work at the University of Pennsylvania. She believed that a campaign for a federal suffrage amendment directed at the president and Congress was a better strategy than the state-by-state approach. Many suffragists found her approach too radical. She persuaded the suffrage association to approve the Congressional Committee (later the Congressional Union), which she headed; she moved to Washington, D.C., to focus the attention of the committee on the federal government. Here she successfully stole the spotlight from the inaugural festivities for Woodrow Wilson. On March 4, 1913, the day before Wilson's first inauguration, she staged a parade of approximately five thousand women up Pennsylvania Avenue from the Capitol building past the White House. A banner carried by the women summed up Paul's goal: "We Demand An Amendment to the Constitution of the United States Enfranchising the Women of the Country."[11]

Alice Paul believed Wilson needed to be persuaded to use

Alice Stokes Paul, ca. 1914. Perhaps the most militant of New Jersey suffragists, Paul (1885-1977) was a fierce campaigner for equal rights. Courtesy NEW JERSEY HISTORICAL SOCIETY.

his influence with the Congress. In 1913, she led a delegation of women from New Jersey to visit the former governor of their home state, but he failed to support her. From then on she was on the attack. For example, during his presidential reelection campaign in 1916, she responded to his slogan, "He kept us out of war," with the motto, "He kept us out of suffrage."[12] Paul held responsible all in "the party in power" for denying women the right to vote. This single-minded viewpoint led her to form the National Woman's Party. By March 1917, there was a New Jersey branch of the organization under the leadership of Alison Turnbull Hopkins.

On January 10, 1917, Alice Paul began the first picket campaign before the gates of the White House and in front of the Capitol. The campaign lasted until the suffrage amendment was passed by Congress and signed by Wilson. For over a year and a half, the "Silent Sentinels," as they were called, demonstrated every day, except Sunday and when Congress was not in session, as a steady reminder of the vote for women. In states where women had the right to vote, Democratic and Republican candidates found they had to encompass the views of the NWP to secure the women's vote.

Discord between the Woman's Party and other women's groups arose when Wilson led the United States into World War I. Alice Paul charged that the United States could not "make the world safe for democracy" when democracy was not practiced at home. The NWP did not support the usual homefront activities of women during the war years. It maintained that suffrage was its single purpose and continued to picket the White House. Though its members participated in the war effort through other organizations, the Woman's Party was accused of being pacifist by organizations like the New Jersey Association Opposed to Woman Suffrage, which tried to equate suffrage with pacifism to discredit the movement. The picketing at the White House became disorderly. Hopkins and Julia Hurlbut, both of Morristown, were arrested and taken into custody during one demonstration in July 1917.

While Alice Paul and the NWP gave no rest to the Wilson administration during the war, the New Jersey Women's Suffrage Association chose to support the administration and its war efforts, although it never abandoned its primary concern for suffrage. Other women's organizations in New Jersey backed

the war effort and formed the Committee of the Council of National Defense. New Jersey women also responded to Liberty Loan drives, the Woman's Land Army of America, food conservation programs, and fund raising for projects such as a soldiers' clubhouse near Fort Dix.

During the war, the suffrage campaign in the state gathered new support. The State Federation of Women's Clubs finally endorsed woman suffrage at its 1917 fall convention and voted to accept as an affiliate the New Jersey State Federation of Colored Women's Club, headed by its founder, the Reverend Florence Randolph of Jersey City. The Equal Franchise League and the Women's Political Union also joined forces with the NJWSA.

As the war progressed and women's war work substantially escalated, a new outlook towards suffrage gradually emerged. Conservative political leaders in the eastern industrial states recognized the value of women's work in various war industries and changed their position on the vote for women. The argument about suffrage and prohibition fell apart once the Volstead Act establishing federal prohibition was passed in 1919 without the women's vote.

President Wilson came to see suffrage as an enduring struggle and women's work on the home front as a reminder of a defect in the democratic structure of the nation. Women's contributions could no longer be ignored; suffrage was an idea whose time had come. On January 9, 1919, Wilson announced his endorsement of the Nineteenth Amendment in the Congress. The measure passed the House of Representatives the next day, and the Senate adopted it on June 4.

The New Jersey Suffrage Ratification Committee, headed by Lillian Ford Feickert, was formed the following month. The committee formally presented a suffrage petition bearing 140,000 signatures to Governor Edward I. Edwards and legislative leaders. The Men's Suffrage Council was also formed. Both advocates and opponents campaigned vigorously over the next months.

Contrary to everyone's expectations, the state senate voted in February 1920 to ratify the Nineteenth Amendment by a vote of eighteen to two, reversing the 1915 referendum. Assembly motions recommending ratification by referendum, rather than legislative approval, were defeated and the opposition withdrew.

Approval in the assembly came in the early hours of February 10, 1920, by a vote of thirty-four to twenty-four, amidst the jubilation of suffragists in the galleries at the State House. New Jersey became the twenty-ninth state to ratify the suffrage amendment.

Conclusion

After the Civil War, more New Jerseyans lived in towns and cities than on farms. The home had long since ceased to be the center of economic production for the family. If a woman did not work outside the home, her major economic role was as household manager and consumer. Many women did work outside the home; industrialization required a new and growing labor force. Class, race, and ethnicity often determined where women worked, or whether they worked at all.

Working-class white women entered the textile industry and worked in factories, department and retail stores, and commercial laundries. By World War I these women held "women's jobs" as typists, secretaries, bookkeepers, waitresses, hairdressers, telephone operators, and salesclerks. African-American women worked as dressmakers, seamstresses, cooks, laundresses, and domestics in the homes of the wealthy. Married immigrant women took in boarders and did piecework at home. Working women were usually exploited. They earned less money than men, in part because they were restricted to less-skilled and lower-paying jobs. Some women were paid less even if they performed the same work as men. Even when their wages were essential for family support, society persisted in regarding women's wages as supplementary.

Many upper- and middle-class women joined the state's reform campaign during the Progressive Era, mostly through their clubs and organizations. They concentrated on issues related to health, education, quality of life, and women's rights. By 1900 many were teachers, nurses, librarians, midwives—following the accepted women's careers—and a few had become doctors, lawyers, scientists, and ministers. Women had expanded their economic role and become involved in all kinds of social reform movements; however, they were still excluded from the political life of the state and the nation. Only the combination of women's sacrifices during World War I and the dogged de-

termination of suffragists like Alice Paul enabled American women to secure the right to vote, restoring to New Jersey women a right lost in 1807.

CHAPTER FOUR

Politics, Wages, and Equality

Women in the United States voted for the first time in the national election of November 2, 1920. The turnout nationally was a disappointment—only 30 percent of the eligible women voters went to the polls. In New Jersey, the League of Women Voters claimed that more than 50 percent of eligible women registered, but the number who actually voted in the state is unknown. Republican Warren G. Harding was elected president, receiving 67.7 percent of New Jersey's votes against 28.4 percent for the Democratic opponent James M. Cox.

The election gave notice that women would not turn out in record numbers or constitute a "bloc" of voters on political issues and candidates. In subsequent elections, women, like men, voted in smaller numbers than expected and they found reasons other than gender for their votes. Economic and political considerations—prosperity, economic depression, war, and economic recovery—have been the major factors affecting women's votes as well as men's.

The Twenties

During the prosperous 1920s, New Jersey's economy re-

mained industrial. The manufacture of textiles, chemicals, electrical machinery, iron, and steel made cities like Newark, Jersey City, Trenton, Passaic, and Camden busy and prosperous. Recent immigrants and African-Americans from southern states found jobs, low-paying and semiskilled, in factories and industrial plants. The means of transportation changed from trains and trolleys to automobiles and buses. New Jersey residents found employment in transportation-related industries such as automobile assembly for General Motors and Ford and construction work at Newark Airport and on the George Washington Bridge, the Bayonne Bridge, and the Holland Tunnel. Although agriculture continued to contribute to the state's economy, only about 4 percent of New Jersey's population worked at farming and total cultivated acreage steadily declined. Truck farming of fruits and vegetables for the canning and frozen food industries, rather than grain production, characterized farming in the "Garden State."

There were many more women in the workplace. While women shared some workplace experiences, they did not all share the same view of their work.

As a group, women earned less for their labor than men. For most women the idea of a career other than marriage and family was foreign. Young middle-class women who had finished high school went on to clerical jobs as typists, bookkeepers, and stenographers or perhaps took posts as retail clerks. Women with more education became teachers or nurses. Some of these occupations, for example most clerical work, had once been dominated by men, but during the nineteenth century they were feminized. As women entered them in large numbers, their status declined. School boards, hospitals, and businesses of all kinds could pay women lower wages for the same work, partly because women traditionally accepted lower wages and partly because women were defined as short-term workers. In society's view, women were not "heads of families"; men were. Therefore, women were paid less. Women were still expected to leave the work force when they married or began a family. Indeed, some were forced to leave. Many school boards, for example, would not hire or even retain married teachers.

Even if women continued to work after marriage, they earned less because women's wages were still considered "supplemental" rather than essential to the family economy. Married

women were assumed to be working for "pin money" or perhaps to earn money for new appliances. Despite the low wages, the number of married women who continued to work did increase. Access to reasonably reliable means of birth control may have made some of this possible. The issue of family planning attracted the interest of many middle-class women even though it was difficult to obtain information legally. The Comstock Law, in force until 1936, outlawed the sending of birth-control information through the mail. The New Jersey Birth Control League was established in 1928. One of its activists, Cora Hartshorn of Short Hills, helped found the Newark Health Care Center which was devoted to disseminating birth-control information to married women.

Working-class women toiling in factories often had little choice about working, whether they were married or single. Many had to work. They were not well educated enough to leave the world of the factory and gender bias confined them to certain jobs. Their jobs required less skill; highly paid skilled work was reserved for men. Labor unions still regarded women with hostility and provided little protection in the workplace; advancement was for the most part closed to them. In addition, domestic responsibilities were still there when they left the factory gates; for many women, a future where their husbands were well paid and they could stay home represented liberation.

Black women, for the most part, could not even enter the factory gates. Their employment profile began and ended with such things as domestic work and jobs in commercial laundries. For them the drudgery of the factory would have represented opportunity.

Women were deeply divided over the question of protective legislation and the Equal Rights Amendment (ERA).[a] The achievement of wages-and-hours legislation was a hard-won victory for Progressive reformers, and many saw the ERA campaign as a threat to all the work they had done to protect women in the workplace. Other activists saw protective legislation as obstacles to women's advancement in the world of work because

[a]The ERA was a proposed constitutional amendment guaranteeing equal rights for women.

it barred women from certain types of jobs, night work and the possibility of overtime.

The 1920s also brought the development of New Jersey's suburbs. Urban middle-class and skilled workers moved to suburbs outside the central cities. Bergen and Essex counties had the greatest population growth. During the 1920s, Radburn in Bergen County was designed as a model residential community for the vehicular age. New housing and commercial businesses developed along commuter routes to the suburbs.

The number of automobiles and bus lines increased. More than eight hundred thousand cars were registered in New Jersey in 1929. In 1923 the Public Service Transportation Company, a subsidiary of the electric and gas utility Public Service Corporation of New Jersey, began to offer bus service at various locations in the state. Earlier, in 1909, Alice Huyler Ramsey of Hackensack became the first woman to drive cross-country. She went from Manhattan to San Francisco, promoting the automobile and women's driving. L. Bamberger & Company, founded in Newark in 1893, was the state's largest department store in 1928 and was already looking toward suburban expansion.

Upper- and middle-class homes had indoor plumbing, central heating, and electric lighting. The home-economics movement, advocated by Lillian Gilbreth of Montclair, encouraged women to use new appliances such as vacuum cleaners, washing machines, and electric irons as well as packaged and canned foods and ready-made clothing. New Jersey newspaper columnist Christine T. Herrick, taking up the career of her mother Mary Hawes Terhune (known as "Marion Harland"), also wrote of the new household technology and helped to make household-advice articles popular. As the new mass-produced appliances became more affordable and domestic service became more costly, middle-class women were cast in the multiple roles of consumer, home manager, domestic, and child rearer. New standards of hygiene and homemaking were imposed by advertisers selling the many cleaning products which appeared on the market. In time these trends filtered down through popular women's magazines to the working class.

Women, who made most of the family purchases, were portrayed as model consumers primarily interested in raising the family standard of living. Refrigerators, packaged foods, and

washing machines permitted the ideal woman to efficiently feed and clothe her family, leaving her ample opportunity for appropriate feminine pursuits—fashion and beauty.

America's postwar discovery of Sigmund Freud and of behaviorists like John B. Watson combined to reinforce women's preoccupation with home and family. Marriage manuals adopted Freud's theories that women were special beings, that they were naturally discontent with their gender and jealous of men, and that motherhood was the only way to overcome this discontent. Watson's method of childraising, which featured rigid activity schedules, required a heavy commitment of a mother's time. If one were to believe what one read, the ideal woman in the 1920s stayed home, had children and organized their time relentlessly, bought many appliances, and paid close attention to fashion.

Social Feminism

Historians are almost unamimous in agreeing that the women's movement lost most of its force following the ratification of the suffrage amendment. Disagreement persists, however, regarding the cause or causes of the decline. The postwar decade of the 1920s was generally a politically conservative period, with the liberal reform spirit of the previous Progressive Era greatly diminished. The suffrage campaign may have actually discouraged further reform, because many women thought having the vote would permit them to solve all their problems. Disillusion with the efficacy of the ballot set in fairly quickly.

The women's movement was dominated by white middle-class women interested in a variety of social reforms. Most were not what we would call feminists. The franchise produced cosmetic improvements, such as the inclusion of women on the national committees of the major political parties, but women made few gains in political office or influence. (New Jersey was somewhat of an exception as we shall see later.) Moreover, the women's movement had no real theoretical base and it did not argue for any alternative to the traditional role of women. For example, there was very little support for Alice Paul's proposal in 1923 for an amendment to the federal Constitution to establish

equality of the sexes and remove gender-based discrimination in all areas of American society. Finally, once the suffrage amendment was ratified, the National American Women's Suffrage Association, which had so successfully organized American women, went out of existence.

Some historians think that the women's movement did not disappear after 1920 but survived through the work of "social feminism."[1] New Jersey during the 1920s and 1930s provides several examples of social feminism. It should be pointed out that the term "social feminism" includes many more women than "female Progressive."[2] Women who have been labeled social feminists both supported and opposed wage and hours legislation. They investigated factory conditions, exposed prostitution rings, worked in settlement houses, and organized workers. They were patricians, working-class activists, Republicans, Democrats, anticommunists, socialists, and anarchists. They covered such a wide class and ideological spectrum that grouping them as one may not be meaningful.

A new national women's organization, the League of Women Voters, was founded by Carrie Chapman Catt. Its objectives were to educate women as voters and to lobby for the passage of legislation. The goals of the new organization proved to be popular, and the league was operating in forty-six states, including New Jersey, by the end of 1920.

The New Jersey League of Women Voters (NJLWV), headed by Agnes Anne Schermerhorn, former leader of the State Federation of Women's Clubs, began its work of voter education with a series of citizenship schools organized by Jennie Van Ness. The league's legislative committee endorsed many social-reform bills, such as child labor and minimum wages-and-hours laws, and lobbied for their passage in Trenton.

As a nonpartisan organization, the league advanced neither the participation of women as political candidates nor their membership in political parties. The league's position was that the ballot was all women needed to influence male politicians and to express their separate views on social issues. For league members, service to society was the way to advance women's issues as well as their use of the ballot. In time, the league's voter registration drives and voter education programs became the hallmarks of its success. By 1940, the league had approximately five thousand members and thirty-two locals, but its

membership never matched that of its predecessor, the suffrage association.

By far the largest state women's organization was the State Federation of Women's Clubs. It doubled its membership from twenty thousand to forty thousand before 1930, and in 1940 it claimed 300 clubs statewide. It continued its cultural programs for women and its legislative lobbying on social issues. Like the league, the federation avoided partisan politics, believing that voting was the only acceptable political activity for women. The federation did not avoid controversial issues, but chose those which best represented its agenda. Throughout the 1920s, it championed the strict enforcement of Prohibition on both the state and national levels to preserve the quality of home life, and it favored legislation for birth control and the sterilization of the feebleminded and criminally insane.

During the 1920s and the 1930s, the women's movement divided over the question of special protective legislation. The Consumers' League of New Jersey, founded in 1904 by reformers connected with Whittier House, took a major role in the debate. The league was interested both in consumer issues and in improving conditions for working women.

The Consumers' League believed that laws barring women from night work and overtime were essential to improve the conditions of employment for women. Such laws would safeguard the rights of working women and recognize that many working women still considered their primary roles to be wives and mothers. The principle of sexual equality might serve professional women, but it did not serve working women who faced rampant discrimination in offices and factories, especially in the "sweat shops" of the garment industry. Special laws alone could make bearable the conditions faced by women who worked out of necessity. Opponents of protective legislation claimed that it excluded women from certain jobs, both jobs they had held during World War I and those higher-paying posts traditionally labeled "men's jobs."

In 1923, the Consumer's League and the New Jersey Women's Republican Club led the way for the passage by the legislature of the "No Night Work Bill." The bill was adopted, though the New Jersey Woman's Party opposed it. The party, which was reorganized after the suffrage campaign, saw protective legislation for women as contrary to the feminist goal of

sexual equality and harmful to equal job opportunities for women. By seeking special treatment in the workplace, women jeopardized their employment and imposed limitations on themselves in the job market. The No Night Work Bill, charged the Women's Party, might not serve the interests of women who wished to work evening hours so they could share child care with their husbands. As passed, the bill contained no provisions for enforcement or punishment for violators. In addition, it could be suspended in time of war or other serious emergency; it was suspended to accomodate women's employment during World War II.

The Woman's Party also championed a legislative program to eliminate legal discrimination against women. It successfully promoted bills that prohibited sex discrimination in the employment of teachers (1925), allowed women to be executors and trustees (1926), permitted women to establish separate legal residences from their husbands (1927), permitted married women to keep their wages and earnings (1928), and gave mothers the right to appoint guardians for minor children by will (1928). This legislation, along with the passage of the Dower and Curtesy Bill (1927), which gave equal inheritance rights to husbands and wives, provided the first real clarification of women's rights since the second Married Woman's Property Act in 1845.

By 1937, the Woman's Party had all but disappeared as an active state organization because its members had turned their attention to the national organization's efforts to pass a federal amendment for equal rights. Other organizations like the New Jersey Federation of Business and Professional Women and the New Jersey Women Lawyers' Club took up the crusade against special protection laws in the state.

Women and Politics

While organization members kept social-reform issues alive in the postsuffrage era, other women in the state entered party politics. In fact, opportunities for women in New Jersey were better than in other states. By 1921, women could hold political office, serve equally with men on municipal, county, and state political committees, and serve as grand and petit jurors in civil and criminal matters.

Eleven women (four Democrats, three Republicans, two Socialists, two State Taxers) were nominated for the state assembly in the first election in which women were eligible to vote. Two Essex County Republicans, Jennie C. Van Ness and Margaret R. Laird, were elected and became the first women admitted to the legislature. (No woman was elected to the senate until 1966.) The number of women in the sixty-member assembly increased to eight in 1927 (five Republicans, three Democrats), and then fell to five in 1940 (four Republicans, one Democrat). At most, there were three or four women serving on the county boards of chosen freeholders between 1925 and 1939. However, the number of women holding seats on county election boards increased from thirteen in 1927 to twenty-six in 1935.

Both political parties were ambivalent about the newly enfranchised citizens. They were eager to accept the new voters to their ranks but were not enthusiastic about women having a voice in party councils. The Republican party named Lillian Feickert vice-chairperson of its state committee in 1920, through which position she organized Republican women by appointing them to the twenty-one county committees. She also founded the New Jersey Women's Republican Club (NJWRC), which received partial funding from the Republican party and boasted a membership of sixty thousand in 1922. This group expressed its own views on proposed legislation for women and recommended issues for inclusion in the Republican party platform.

The Democrats, on the other hand, recruited women to the party through the regular party clubs or through women's auxiliaries. They also set up a women's division of their state committee. Unlike the Republicans, however, they developed no formal structure at the county or state level and had no state organization for women. Even where Democrats were strong (in urban-industrial and heavily immigrant areas) it took years for the number of female members of the Democratic Party to increase. On the other hand, the Republicans immediately drew in the middle-class native-born Protestant women of the suffrage movement ready for political participation.

In 1924 Mary T. Norton became the first New Jersey woman elected to Congress and the first woman Democrat in the House of Representatives. Her entry into politics resulted from her appointment by Mayor Frank Hague of Jersey City to the

Hudson County Board of Freeholders in 1923 and from her service as the first woman member of the Democratic State Committee. She continued as a freeholder until 1949.

Norton believed that women should participate in the local political party rather than in nonpartisan women's organizations, and she became the Democrats' role model of the newly enfranchised woman. To encourage women's involvement in politics, Norton's message was: "Any woman interested in the welfare of her own family and her own community is interested in politics."3

In the House of Representatives, where Norton served from 1924 to 1950, she earned a mixed reputation on women's issues. She opposed the Gillette Bill for the dissemination of birth control information, but during World War II she championed the passage of the Lanham Act providing federal funds for day-care centers. As chairperson of the House Labor Committee, she shepherded the Fair Labor Standards Act to passage in 1938. The bill established the first federal maximum-hour and minimum-wage standards for men and women in industries involved in interstate commerce. It affected factory work but not sales, service, domestic, or agricultural work. Norton never supported the Equal Rights Amendment because she favored separate protective legislation for working women. However, in 1940 she conceded that the amendment might be submitted to the states for ratification.

The Depression

In 1930, New Jersey's population was just over four million, or more than double what it had been in 1900. That rapid growth declined in 1930s due to restrictive immigration laws and economic depression.

New Jersey and other industrial states were hit hard by the Depression. Factories and businesses closed, people lost their homes and businesses. Tens of thousands of New Jersey residents went on relief or turned to the state and federal public works programs for jobs. By 1936, nearly a hundred thousand men and women were on the Works Progress Administration payroll, but it wasn't enough. Nearly seven hundred thousand were unemployed.

The employment situation was so bleak that working women

were asked to leave their jobs. Most Americans were opposed
to the employment of women and believed that they took jobs
away from men. The belief that women did not work from
necessity but for "extras" was embodied in the slogan, "don't
steal a job from a man."

Despite the propaganda, women continued to work when and
where they could. Married women needed jobs to help their
families through hard times and disregarded negative public
sentiment. Single, widowed, and divorced women needed to
work because they were often their families' sole support. The
customary segregation of men and women in the job market
made the argument against women's employment illogical. On
the whole, men would not do so-called "women's work," namely
retail sales, clerical, domestic, or service jobs. These jobs re-
mained vacant when women did leave them.

Many women could neither find nor keep jobs. They had no
choice but to return to the traditional nonpaying homemaking
chores of laundry, clothes mending, and food preparation, and
to try to make their husbands' smaller paychecks stretch. Black
women found white women competing with them for jobs which
had traditionally belonged to blacks. Employers reduced the low
salaries for domestic work to even lower levels. Black women
found themselves waiting on street corners in the morning for
white women to offer them a day's work.

Federal laws passed during the 1930s prohibited more than
one family member from working in federal civil service, and
state governments, private businesses, and labor unions sought
to follow the federal lead. Women achieved a major victory in
New Jersey in 1936 when the Woman's Party successfully op-
posed a bill extending the provisions of the 1932 Economy Acts
to state government. The bill would have prohibited the state's
employment of both a man and his wife.

Other New Jersey women's organizations worked to soften
the effects of unemployment for women and their families. In
1932, the Consumers' League established a labor standards
committee to investigate the welfare of working women. The
committee found that employers used economic hardship as an
excuse for ignoring labor standards and state protection laws
for women. It recommended the enforcement of the laws as
part of the state government's effort to cope with unemploy-
ment. If a forty-eight-hour work week for women in certain

trades was approved, the league held, the state economy would be aided by an increase in the number of jobs. Furthermore, a minimum wage bill for women would raise women's salaries and along with it their power to purchase consumer goods.

In 1933, a coalition of women's organizations and the State Federation of Labor persuaded the legislature to approve minimum-wage standards for women and minors and limit the number of hours women and children could work in certain industries. New Jersey was one of seven northeastern states to adopt such measures that year, but it did not fund its plan until 1936.

World War II

Public-relief programs sponsored by the federal government did not rally the economy. Improvements came in the late 1930s through the nation's role as the "arsenal of democracy" as Europe approached war, and finally when the United States entered World War II. War contracts created a demand for women and men to work in power plants, explosives factories, communications and radio firms, and in airplane and battleship production.

The onset of World War II changed attitudes about working women, at least for the duration of the war. Efforts to secure protective legislation ceased, and many state governments suspended the protective laws already in place. Once attention was focused on international affairs, lobbyists for a whole range of "women's issues" found their influence diminished.

The war brought drastic changes in the lives of American women. Six million women went to work for the first time, and the workforce, for the first time, included more married women than single women. Women were encouraged to find employment for patriotic reasons. Newspapers, magazines, radio programs, and the movies portrayed working women as patriotic paragons of virtue. Women who did not take "regular jobs" were expected to raise victory gardens at the least, or to roll bandages for the Red Cross.

For the first time, Americans saw women in military uniforms. Women in the military were noncombatants but the Army, Navy, Marines, and Coast Guard all had women's corps. Acronyms like WAC (Women's Army Corps) and WAVE (Women

Accepted for Volunteer Emergency Service) entered the
language. Government, at least in principle, accepted the idea
of equal pay and promoted the establishment of child-care
centers.

The actual situation was not as bright. The National Labor
Relations Board did not enforce equal-pay directives effectively,
so employers ignored them. Moreover, while the Lanham Act
of 1943 established federally funded day-care centers for the
children of women employed in defense work, the centers
benefited few children. The one hundred thousand children
enrolled in 1945 were only a tenth of the number who needed
places.

The need to supply war matériel provided a great many jobs.
The demand for manufactured goods spurred New Jersey's
economy as no financial measure could. Industrial plants—from
explosives factories to iron mines and petroleum refineries—
started up again in full force. In 1943 the state ranked fifth
in federal war contracts. It had 7 percent of the total, or $12
billion worth of all government contracts.

Responding to the labor shortage caused by the war effort
and to a request from the federal Office of Production Manage-
ment, New Jersey modified or waived protection laws to allow
women to lift heavy objects on the job and work nights and
overtime. The reclassification of jobs did not bring women the
same pay that men had earned, but it did reduce, at least
temporarily, the number of sex-segregated jobs. More and more
women workers were found in government offices, as well as
in defense plants and private industries as welders, riveters, and
crane drill-press operators. Black women, like their white
counterparts, joined the industrial workforce. They earned more
than they would have earned in domestic service, but many
earned less than white women and they were often assigned
to the filthiest and most hazardous jobs.

Although much has been claimed for "Rosie the Riveter,"
most women remained homemakers. They contributed to the
war effort as volunteers in bond drives, civil defense work, on
ration boards, and for the Red Cross. They learned to contend
with shortages of consumer goods like automobiles, sugar, meat,
and nylons, as well as with rationing and price controls. Women
were celebrated for their patriotism, either because they filled
in for men in the workplace or because they made other

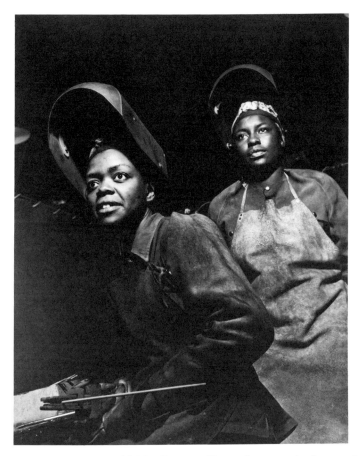

Two welders, 1943. *World War II sent millions of men to the front and required production of vast amounts of airplanes, tanks, and the like. Many women entered the work force for the first time. Black women found new opportunities for work in industries which had traditionally employed only white males. Photograph by GORDON PARKS for the OFFICE OF WAR INFORMATION. Courtesy of the LIBRARY OF CONGRESS.*

sacrifices. However, the assumption was that this would all end once the war was over. Women, it was assumed, were "waiting for the boys to come home" to resume family life as usual. In reality, the war placed a heavy burden on women. It disrupted

their family lives and marriages, increased the divorce rate, and made the equality issue a low-priority item for state and national governments.

Women's gains during the war were temporary. Their improved status and pay evaporated once the war ended. Women's employment was sharply cut back by the closing of war-related plants and by employers' preference for returning soldiers. Those who continued to work gradually returned to traditional and low-paying jobs in offices, sales, and service. Black women had widened their area of employment beyond domestic service to service jobs in hotels and restaurants and industrial work in munitions plants, foundries, and clothing factories. They found it difficult to break into the clerical field in the private sector. Most of the clerical jobs available to blacks were with the federal government. For example, Bell Telephone Company in Newark did not even hire its first black operator until 1946. White-collar work in the private sector remained out of reach for all but a token few until the 1970s.

Equal Rights

During the 1920s and the 1930s, two New Jersey women had managed to focus some attention on the issue of sexual equality. They were Alice Paul on the national level and Mary Philbrook on the state level. In 1923, Paul proposed a federal amendment, the Equal Rights Amendment, to end discrimination on the basis of sex. Through her dogged determination and that of the Women's Party, the amendment was introduced into every Congress for the next forty-nine years. Paul and Philbrook persevered despite a lack of support. In the 1920s and the 1930s most national women's organizations opposed the amendment, as did state chapters of the League of Women Voters, Consumers' League and Federation of Women's Clubs.

Mary Philbrook, who had met Alice Paul during a suffrage demonstration, championed the cause of the ERA and the principle of sexual equality. Philbrook was the first woman attorney to apply to the New Jersey bar. Like many other attorneys, Philbrook "read" law in another attorney's office rather than attending law school. She was denied admission to the bar in 1894 because there was no enabling legislation permitting women to practice law in the state. New Jersey suffragists

Mary Philbrook (1872-1958). Philbrook, pictured here in 1904, was the first woman admitted to the New Jersey bar. She was a tireless campaigner for equal rights and also worked in the area of women's education and judicial and prison reform. Courtesy NEW JERSEY LAW JOURNAL.

took up her cause and persuaded the legislature to pass the necessary bill. She was finally admitted to the bar in June 1895, and in 1906 she became the first woman to be admitted to practice law before the United States Supreme Court.

Philbrook's first campaign for the legal rights of New Jersey women was an attempt to regain the right to vote which they had enjoyed under the 1776 state constitution. Despite her arguments, the New Jersey Supreme Court ruled in 1912 that the language "all citizens" in the 1776 constitution did not include women, that voting was "nothing more than a privilege emanating from a legislative act, which a subsequent legislature had a right to repeal, and later did repeal—the right to vote was conferred only on the male inhabitants."[4] Even after the adoption of the Nineteenth Amendment, the word "man" was not removed from the state constitution. Philbrook also believed that women should be given equal treatment under the law, not the special treatment embodied in protective legislation. She directed the activities of the New Jersey Woman's Party for many years and founded several single-purpose women's groups in pursuit of this goal. Under her leadership, the New Jersey Committee to Eliminate Discrimination Against Women proposed an equal-rights amendment to the state constitution in 1939. It passed the assembly but was defeated in the senate.

The following year, the League of Women Voters called for a complete revision of the state constitution, which the voters approved in a November 1943 referendum. The work of revision fell to an advisory board of the Joint Legislative Committee appointed by Governor Walter E. Edge, a Republican. Philbrook proposed the inclusion of an equal-rights clause in the new constitution. When she could not persuade her party to include the clause, she swung her support and that of several women's groups to the Democrats and helped defeat the constitution.

She had another chance in 1947 with another constitutional-reform movement led by another Republican governor, Alfred E. Driscoll. Philbrook organized a coalition of women's groups, the Women's Alliance for Equal Status, to lobby for the equal-rights clause at the Constitutional Convention in New Brunswick. The League of Women Voters, the New Jersey Federation of Women's Clubs, and several other large organizations opposed the clause because it was a threat to protective legislation.

However, membership in the professional organizations which made up a large part of Philbrook's coalition had grown a great deal, and the Women's Alliance was able to claim that it spoke for more than twenty-eight thousand members, making it a powerful lobby.

The delegates did not really oppose the clause, but they wanted to avoid offending large established organizations like the League of Women Voters. So they compromised, avoided the mention of gender at all, and substituted the word "person" for the word "he" everywhere in the constitution. The expression "equal rights" appeared nowhere in the document. The elimination of gender designation technically recognized women's equality with men. According to Philbrook's biographer, "Few people are aware ... that the constitution that was adopted contained language that was intended to provide equal rights for women."[5] The Constitution of 1947 was adopted by a vote of 653,000 to 185,000.

Recovery and Feminism Renewed

In the 1950s New Jersey's population grew faster than the nation's by more than a fourth. A combination of the postwar "baby boom," and the influx of residents from other states propelled the population total to over 6 million in 1960. The state's black population increased more than any other segment, most migrating from southern states in search of employment.

New Jersey's suburban population grew by 47 percent. Poor white, black, and Hispanic residents remained in the state's urban centers to face the deterioration of housing and community services while more affluent families, most of them white, moved farther out into the suburbs. Affordable land and financing through the GI Bill for veterans and the Federal Housing Administration encouraged home buying in former rural areas. The opening of the Garden State Parkway and expansion of the New Jersey Turnpike southward paved the way for a suburban sprawl to housing developments like Levittown (now Willingboro) in Burlington County.

Americans who had been able to buy few consumer goods during the war went on a consumer binge in the postwar era. Installment plans for the purchase of dishwashers, garbage disposals, hi-fis, and the second car gave new meaning to shop-

ping. Suburban homemakers transported children to school, music lessons, and Little League and devoted themselves to volunteer work for parent-teacher organizations, the League of Women Voters, and church and community organizations. Magazines featured articles on family life ("Can This Marriage Be Saved?"), household management and decoration, recipes, and changing hemlines and hairdos. Television, paperback books, and movies portrayed the typical family as working husband, stay-at-home wife, two children, dog, and immaculately kept home. The wife wore a dress, heels, and full makeup. In the nuclear-age version of domestic bliss, the family's problems were usually minor and the woman was always decorative and perfectly content with her role.

Women lauded for their patriotic efforts in the workplace during the war found the tables turned in the postwar years. Now women who worked were attacked for destroying the family. Women could not win. Philip Wylie in a 1942 book, *Generation of Vipers,* had excoriated women for their tyranny over husbands and sons. In 1947 Maryann Farnham and Ferdinand Lundberg wrote *Modern Women: The Lost Sex* and blamed all of society's problems on the fact that women had left the home.

Despite the emphasis on domestic bliss, the number of women in the workplace increased, particularly in low-paid part-time jobs. Easy access to birth-control pills permitted married women to plan their families. In 1950 the average woman married at 20 and had her last child at 26. When her last child went off to college, she was only in her early 40s. The percentage of working married women went from 15 percent in 1940 to 30 percent in 1960.[6]

Ironically, suburban domestic bliss demanded that women work. Consumer taste for new cars, dishwashers, and music lessons for the children required money. One salary, particularly as the economy lurched from inflation to recession, could not cover the costs. By 1960, 35 percent of all American women worked and they made up one-third of the labor force. A decline in the birth rate and an increase in higher education for women—they constituted 36 percent of all undergraduates—contributed to their increased presence in the work place.

Married women workers, with or without children, out-numbered single women workers. The classification of low-wage

jobs in office, sales, and services as "female" kept a majority
of women out of professional occupations. Black women work-
ers advanced into clerical work, but most black women con-
tinued to labor under the double burden of race and sex
discrimination. During times of economic distress, women and
all blacks were the last hired and the first fired. In general,
although more women worked, they were still not treated as
either permanent or equal partners in the market place.

By the 1960s there was new controversy over women's role
in society. Betty Friedan's *The Feminine Mystique,* published in
1963, exposed the idealization of the lives of white middle-class
women and women's general condition of "role confusion." In
her critical description of how marriage and motherhood did
not provide the same satisfaction and happiness for all women,
Friedan addressed "a strange discrepancy between the reality
of our lives as women and the image to which we were trying
to conform."[7] When the Commission on the Status of Women,
appointed by President John F. Kennedy, reported its findings
in 1963, it pointedly commented on the discrimination against
women in government, education, and employment. The
Federal Equal Pay Act adopted that year specified equal pay
to men and women for equal work, but it did nothing to address
the inherent injustice of a sex-segregated labor force.

The following year the word "sex" was added to Title VII
of the federal Civil Rights Act. That meant that at least in
theory, women were entitled to equal treatment in the work-
place. For example, stewardesses could not be fired upon pass-
ing a certain age. Jobs could not be advertised specifically for
men or for women. Concern over enforcement of the amend-
ment prohibiting employment discrimination prompted Betty
Friedan and other women to found NOW (National Organiza-
tion for Women) in 1966. Its purpose was "to take action to
bring women into full participation in the mainstream of Ameri-
can society now ... in truly equal partnership with men."[8] The
women's movement revived with the founding of state and local
chapters of NOW as well as other feminist organizations.

The movement for women's rights gained strength on the
state level in the 1970s. In 1972 New Jersey's 122-year-old
abortion law was ruled unconstitutional because it was vague
and an invasion of privacy. Under the old statute, abortions were
allowed only to save the life of the mother. The court found

that the law interfered with the physician's "right of privacy" to practice his/her profession. Controversy over the ruling involved the New Jersey abortion and birth control coalitions, the American Civil Liberties Union of New Jersey, the New Jersey Catholic Conference, and the New Jersey Birthright Committee.

In 1972 Congress adopted the Equal Rights Amendment. But the amendment stirred concern for protective legislation such as minimum wages and maximum hours for women workers, as well as worries over questions of alimony, child custody, child support, and the possibility of compulsory military service for women. The New Jersey legislature voted approval of the federal ERA in 1972, but the amendment failed to receive approval by the required three-fourths of the states for ratification.

In 1974, a New Jersey court ruled that since Little League teams used public facilities for recruiting and game purposes, the league constituted a "public accommodation" and had to admit girls. In the case, presented by the Essex County Chapter of NOW, the court dismissed arguments claiming that girls were more susceptible to injury than boys at little-league age. Several months later, as a result of the New Jersey ruling, the Little League national officials announced that girls would be permitted to play on Little League teams with boys.

In the following year, New Jerseyans rejected the addition of an equal-rights amendment to the state constitution. The assembly passed the amendment 57–14, and the senate 33–1 in a concurrent resolution. However, the voters rejected it after a short, heated controversy over women's rights in the state. Supporters of the measure, noting that fifteen other states had approved equal-rights amendments, asserted that such amendments protected the rights of citizens in the absence of a federal equal-rights amendment.

Opponents of the state ERA formed the Citizens Alliance to Stop ERA and claimed the amendment was unnecessary because women were protected both under the Fourteenth Amendment and civil rights legislation passed in the 1960s and 1970s. They also reminded voters that the 1947 constitution was written with the words "person(s)" and "people" to include *both* sexes. In its literature, the alliance also argued that a state ERA would invalidate nearly a thousand New Jersey laws referring to sex, and would leave open to debate the rights of married

women and widows, protective labor laws, social security benefits, insurance rates, pension programs, and right to privacy in hospitals, schools, and public toilets. Finally, they added that the ERA was backed by radical women and the media, intent upon destroying home and family. These arguments proved the more convincing.

After the state and federal ERA amendments were defeated, New Jersey's women's rights supporters campaigned for antidiscrimination measures on the state level. In 1978 the legislature established the New Jersey Commission on Sex Discrimination in the Statutes to examine legislation affecting sexual equality and discrimination. The bipartisan commission recommended revisions in state laws affecting employment, housing, pensions, insurance, and family life. It also advanced new state legislation regarding child support, child care, and domestic violence. The commission's detractors asserted that its main intent was to keep alive the purposes of the ERA.

For many Americans the women's movement posed a threat to traditional family values. Some writers identified the women's movement as antifamily, blamed it for the rising divorce rate, and linked both it and the Equal Rights Amendment with lesbianism and abortion, two things that deeply disturbed many Americans, both women and men.

Proponents of the ERA were unable to allay these fears. Several state legislatures voted not to ratify and the effort to add the Equal Rights Amendment to the Constitution failed.

Feminization of Poverty

The 1960s and 1970s brought bad economic news for many women. The number of female-headed households increased, due both to the rising divorce rate and to the growing number of unwed mothers. The move to no-fault divorce reduced alimony payments for a whole class of women ill-prepared to support themselves. Many women were not qualified for anything other than marginal employment. The number of pregnant teenagers increased; young unwed mothers faced a bleak future on welfare. Half of all working women had low-paying clerical jobs. The wages of full-time women workers remained less than two-thirds those of men in the 1970s. Women's jobs alone rarely

brought home enough to support a family. Increasingly, poverty
was feminized.

The number of jobs in machine production, steel processing,
and automobile assembly in New Jersey declined sharply as hard
times hit those industries in the 1970s and 1980s. Heavy
manufacturing—traditionally a major part of New Jersey's
economy—declined in importance, and the service sector grew.
A record number of women entered the labor force, making
the 1980s the "decade of the working woman," but many were
in lower-paying service-sector jobs.

In 1986, 55 percent of all American women were in the work
force; 54.9 percent (1.6 million) of New Jersey women were
employed, keeping pace with the national trend. One in six
families was headed by a woman. A majority worked in what
has become traditional women's employment—sales, service,
and factory work, or clerical, teaching, library, nursing, and
social work. However, women have also entered the professional
fields of medicine and law and the new high technology in-
dustries—chemicals, pharmaceuticals, trade, communication,
and finance. By the 1980s New Jersey's economy was no longer
dominated by manufacturing but by service and high-technology
companies.

Conclusion

After women obtained the vote in 1920, their course in society
was far from settled. Suffrage had provided a point of agree-
ment for diverse groups of women. Once that was achieved,
class, race, and ethnicity seemed more important than gender.
Women could not find an issue that promoted general agree-
ment.

In New Jersey, a few women entered the political arena in
the 1920s, but women never approached parity with men. Taking
the legislature as an example, there have never been more than
three (7.5 percent of total) women in the senate or more than
seventeen (21 percent) in the assembly at one time.

Organizations such as the League of Women Voters, the State
Federation of Women's Clubs, and the Woman's Party,
representing tens of thousands of women, lobbied and debated
the merits of protective legislation, the Equal Rights Amend-
ment, and similar issues to correct inequities. The high point

of their political effectiveness may have been the revision of the state constitution in 1947 to make the document gender-free, as, whether by design or accident, New Jersey's 1776 constitution had been.

Women joined the work force in large numbers during World War II, and their work was hailed as patriotic. Many of them enjoyed the work, their independence, and the money they made. They wanted to keep their jobs, but few could. Once the war was over they were expected to return to a more traditional role, and most did. Postwar consumerism and the expansion of the economy provided the impetus and the opportunity for women's employment, though mostly in lower-pay or part-time jobs. The fact that many women found their domestic role confining and dull and their lives unfulfilled became clear with their reaction to the publication of Betty Friedan's *Feminine Mystique* in 1963. For many women, Friedan was a heroine who at last had given their frustration a public voice. For other women and a great many men, Friedan was a homewrecking subversive.

As the feminist movement grew in the 1960s, women struggled with economic and social causes as well as political ones. State and national statistics revealed a growing number of women in the labor force, placed there by such diverse economic and social factors as recession, their husbands' unemployment, a higher divorce rate, lower birth rate, single parenthood, increased education, and the drive for individual growth and satisfaction.

Contemporary feminism has neither a massive organization nor a single issue to champion. Women continue to struggle at all levels for reproductive freedom, equal access to education and employment, child care assistance, and equal pay for work of comparable worth.

CONCLUSION

From the beginning, women have played an important part in the development of the state and nation. They have done so despite political, economic, and social restrictions.

In the eighteenth century, women had few legal rights. Married women were subservient to their husbands, they could not hold property, they could not make wills, they could not divorce, and they could not vote. Single women and widows seemed to be in a better position legally (for example, they could own property and in New Jersey some voted). But in a society that considered marriage the proper state for all women, women without legal partners suffered; most had great difficulty supporting themselves. On the whole, women devoted themselves to domestic responsibilities; whatever power they had within the family or whatever influence they mounted locally came largely because they were admirable "goodwives."

Women began to expand their sphere of activities in the nineteenth century. Educational opportunities for women grew, and legal restrictions on inheritance and divorce eased. As New Jersey industrialized, more women entered the workplace—in New Jersey, the textile mills. Marriage and family were still the accepted goals for young women, even educated young women. Most of the female workforce was single; women who married usually left the mills, though they may not have stopped working for pay. More affluent women, who did not have to work for pay, concentrated on home and family. They tried to make their homes safe refuges from the corrupt world of commerce and politics.

Other upper- and middle-class women maintained concerns beyond the exclusively domestic. They formed associations and clubs. They worked for prohibition, against slavery, for better living and working conditions, and for the vote. In so doing,

106

they focused some of their attention outside the home. They set about trying to reform society. Lessons learned in the work for social reform—how to organize and exert political pressure—were used in the struggle for woman suffrage.

The celebration of domesticity was beyond the experience of the poor. The wives and daughters of poor and immigrant families toiled in mills, took in boarders, and did piecework at home in an attempt to supplement the meager earnings of their menfolk. Industrialization brought with it dreadful and unsafe working conditions and low pay. Workers' efforts to organize met with mixed success. The union movement had gained a great deal of strength by the early twentieth century, but initially unions made little attempt to organize women. Union officials and many male workers viewed working women as an economic threat.

During the Progressive Era and into the 1930s, thousands of New Jersey women were active in clubs and organizations which pushed for the passage of social-reform measures. Many of the reformers were neither radicals nor suffragists. They viewed the ballot as essential to accomplish their social-reform goals and lent their energies to the state suffrage campaign.

Despite intense efforts, women did not manage to secure the right to vote until 1920. Society countenanced women in the workplace because a growing economy required those workers, and women's work for social reform was acceptable because a concern with prohibition, child welfare, and tenement housing seemed somehow feminine. Society resisted giving women the right to vote, however, because it persisted in seeing them as dependent and easily influenced. Once the vote was won women seemed to be without a cause on which they might agree. Economic crises and two world wars dominated the national consciousness. Women went to work in large numbers during the Second World War, but those employment gains were temporary. In the post–World War II period, many women returned to a preoccupation with home and family. Magazine articles told them their only role was to be a wife and mother. Experts advised them that the truly feminine woman did not want independence—a career, higher education, or increased political rights. The feminine woman devoted herself to getting and keeping a husband, running a beautiful home, and raising perfect children. As she shepherded her children to Girl Scouts,

birthday parties, gymnastics, and Little League, she had little
attention to spare to the problems of a wider world. Feminists
launched a movement in the 1960s and 1970s that tried to show
women there was a world beyond the home. They strove to
eliminate sex discrimination in the workplace, improve child
care, and end sexual harassment. Many men and some women
found feminism a threat; some were simply baffled. An anti-
feminist backlash has delayed the achievement of equal rights.
A more ominous fact is that women now make up the major
component of the nation's poor. The number of female-headed
households has increased, spurred by a rising divorce rate and
an increasing number of unwed mothers.

There have been important steps towards equality in New
Jersey. In 1950, Katherine Elkus White became the first woman
elected mayor of a New Jersey city (Red Bank), and in 1958
Madaline Worthy Williams became the first black as-
semblywoman. Princeton University began to admit women
undergraduates in 1969 and Rutgers College went coeducational
in 1972. State chapters of the National Organization for Women
and Women's Equity Action League were founded in the late
1960s. New Jersey elected a woman governor, Christine Todd
Whitman, in 1993.

New Jersey has moved to end sex discrimination in the
categories of personal credit, home financing, housing, in-
surance, education, and employment. These are major ac-
complishments, but the women's movement seems stalled. Oc-
cupational opportunities have expanded for the educated
woman, whatever her race. The future looks much bleaker for
the undereducated and the poor. The women's movement, and
society in general, has found no effective way to address the
problems of women caught in a pink-collar world or those of
pregnant teenaged dropouts. Moreover, society has not made
a concerted effort to help women balance the demands of work
and family. Neither government nor the private sector has dealt
effectively with the need for child care for working women or
women who would like to work.

The economic slump and corporate and government downsiz-
ing of the early to mid-90s affected both men and women in
most areas of the economy. Both the national and state economy
began to recover in the late 1990s with a corresponding drop
in the numbers unemployed. Service sector work showed the

most growth, a category that includes both skilled, well-paid work and unskilled jobs with lower salaries.

Women have made great strides in terms of employment. For example, if there are still few women CEOs, there are an increasing number of women in upper management. Even at a time of relative prosperity, the economy poses a central question to both women and men. Will it continue to grow and offer both the opportunity for good jobs with decent salaries— the wherewithal to maintain their families and build decent lives?

NOTES

Full citations are found in "Sources," p. 112.

Chapter One

1. Wright, *Afro-Americans in New Jersey,* 21.
2. Wells, *Population of the British Colonies,* 137–38.
3. Blackstone, *Commentaries on the Laws of England,* 154.
4. Boyd, *Fundamental Laws and Constitutions of New Jersey,* 54.
5. Ibid., 62.
6. Jones, *The Quakers in the American Colonies,* 409.
7. The town seems actually to have been founded earlier by Francis Collins, and named for Elizabeth's father, John Haddon. Current research by Elizabeth Lyons may settle the question once and for all.
8. Gerlach, *New Jersey in the American Revolution,* 284.
9. Evans, *Weathering the Storm,* 47.
10. Ibid., 48.
11. Fridlington, "A 'Diversion' in Newark," 76–77.
12. Gerlach, *New Jersey in the American Revolution,* 350.
13. Boyd, *Fundamental Laws and Constitutions,* 158.
14. Norton, *Liberty's Daughters,* 191.
15. Chute, *The First Liberty,* 59.
16. Norton, *Liberty's Daughters,* 191.
17. Taylor, "Women and the Vote in Eighteenth-Century America," 16–17.
18. Philbrook, "Woman's Suffrage in New Jersey Prior to 1807," 90.
19. Chute, *The First Liberty,* 289–90.
20. Boyd, *Fundamental Laws and Constitutions,* 31.

Chapter Two

1. Powers, "Female Education," 12, 16.
2. Welter, "Cult of True Womanhood," 225.
3. Bole and Johnson, *The New Jersey High School,* 17.

4. "Catalogue of Newark Young Ladies' Institute," August 1835. n.p.
5. Epler, *The Life of Clara Barton,* 21.
6. Welter, "Cult of True Womanhood" and Kraditor, Introduction, *Up from the Pedestal.*
7. Quoted in Epstein, *The Politics of Domesticity,* 85.
8. Weiss, *Life in Early New Jersey,* 53.
9. Hirsch, *Roots of the American Working Class,* 39.
10. Ibid., 40.
11. Wright, *Afro-Americans in New Jersey,* 82–84; Zilversmit, *The First Emancipation,* 222.
12. Boyd, *Fundamental Laws and Constitutions,* 168.
13. Marshall, *Dorothea Dix, The Forgotten Samaritan,* 107–08.
14. Kirchman, "Unsettled Utopias," 32.
15. Abigail Goodwin to "Dear Friend," 10 February 1858, quoted in Still, *The Underground Railroad,* 617, 621, 617.

Chapter Three

1. Hays, *Morning Star: A Biography of Lucy Stone,* 153.
2. Quoted in Foner, *Women and the American Labor Movement,* 1:450.
3. Ibid., 1:452.
4. Dodyk, "Winders, Warpers and Girls on the Loom," 93; Dodyk, "Women's Work in the Paterson Silk Mills," 24.
5. Schmidt, *Douglass: A History,* 4.
6. *Report of the State Board of Education ... 1870,* 39.
7. Martin, *The History of the Newark Female Charitable Society,* 31.
8. Graw, *Life of Mrs. S. J. C. Downs,* 166–67, 79.
9. "Gov. Fielder's Vote Is Not for Suffrage," *New York Times,* 14 October 1915.
10. Peck, *Carrie Chapman Catt,* 259.
11. Irwin, *The Story of Alice Paul,* 30.
12. Ibid., 178.

Chapter Four

1. Lemons, *The Woman Citizen,* viii–ix.
2. Cott, "What's in a Name?" 809–29.
3. Paxton, *Women in Congress,* 36.
4. Petrick, "Mary Philbrook: The Professional Woman and Equal Rights," 57.
5. Petrick, *Mary Philbrook: The Radical Feminist in New Jersey,* 53.
6. Banner, *Women in Modern America,* 243.
7. Friedan, *The Feminine Mystique,* 11.
8. Norton, *Major Problems in American Women's History,* 397.

SOURCES

Chapter One

Lura Anderson, "Life in the Raritan Valley, 1775–1800," *Proceedings of the New Jersey Historical Society* 55 (1937): 277–89; Alfred Hoyt Bill, *A House Called Morven: Its Role in American History* (Princeton, 1878); William Blackstone, *Commentaries on the Laws of England* (New York, 1877); Walter Hart Blumenthal, *Women Camp Followers of the American Revolution* (1952; reprint, New York, 1974); Sally Smith Booth, *The Women of '76* (New York, 1973); Julian P. Boyd, *Fundamental Laws and Constitutions of New Jersey* (Princeton, 1964); Lydia Maria Child, *Elizabeth Haddon: A True Narrative of the Early Settlement of New Jersey* (Philadelphia, 1898); Marchette Chute, *The First Liberty: A History of the Right to Vote in America, 1615–1850* (New York, 1969); J. Clement, ed., *Noble Deeds of American Women* (New York, 1974); Elizabeth Cometti, "Mary Ludwig Hays McCauley," *Notable American Women,* ed. Edward T. James, Janet Wilson James and Paul S. Boyer (Cambridge, Mass., 1971), 2:448–49 hereafter *NAW;* Jemima Condict, *Jemima Condict, Her Book* (Newark, 1930); David L. Cowen, *Medicine and Health in New Jersey* (Princeton, 1964); Linda Grant De Pauw, "The Forgotten Spirit of 1776: Women of the Revolutionary Era," *Ms. Magazine* (July 1974): 51–56 and *Founding Mothers: Women of America in the Revolutionary Era* (Chicago, 1975); Sophie H. Drinker, "The Two Elizabeth Carterets," *Proceedings of the New Jersey Historical Society* 79 (1961): 95–110 and "Votes for Women in Eighteenth Century New Jersey," *Proceedings* 80 (1962); Mary Maples Dunn, "Women of Light," in *Women of American History,* ed. Carol Ruth Berkin and Mary Beth Norton (Boston, 1979), 114–36; Elizabeth F. Ellet, *The Women of the American Revolution* (New York, 1850); Elizabeth Evans, *Weathering the Storm: Women of the American Revolution* (New York, 1975); Robert Fridlington, "A 'Diversion' in Newark: A Letter from the New Jersey Continental Line, 1778," *New Jersey History* 105 (Spring–Summer 1987): 75–78; William J. Frost, *The Quaker Family in Colonial America: A Portrait of the Society of Friends* (New York, 1973); Larry R. Gerlach, ed. *New Jersey in the American Revolution,*

1763–1783: A Documentary History (Trenton, 1975); Harry C. Green and Mary W. Green, *The Pioneer Mothers of America* (New York, 1912); Rufus M. Jones, *The Quakers in the American Colonies* (New York, 1911); Robert Riggs Ker, "Costumes with New Jersey Interest," *Proceedings of the New Jersey Historical Society* 74 (1956): 52–56; Linda Kerber, *Women of the Republic: Intellect and Ideology in Revolutionary America* (Chapel Hill, 1980); Aaron Leaming and Jacob Spicer, *Grants, Concessions and Original Constitutions of the Province of New-Jersey* (Philadelphia, 1756); Alma Lutz, "Elizabeth Boudinot Stockton," *NAW,* 3:342–47; Richard P. McCormick, *The History of Voting in New Jersey* (New Brunswick, 1953); Gerald D. McDonald, "Elizabeth Haddon Estaugh," *NAW,* 1:584–85; Margaret Hill Morris, *Private Journals Kept During the Revolutionary War* (1836; reprint, New York, 1969); Mary Beth Norton, *Liberty's Daughters: The Revolutionary Experience of American Women, 1750–1800* (Boston, 1980); William Davison Perrine, *Molly Pitcher of Monmouth County, New Jersey and Captain Molly of Fort Washington, New York* (Princeton Junction, N.J., 1937); Mary Philbrook, "Woman's Suffrage in New Jersey Prior to 1807," *Proceedings of the New Jersey Historical Society* 57 (1939): 87–98; J. R. Pole, "The Suffrage in New Jersey, 1790–1807," *Proceedings of the New Jersey Historical Society* 71 (1953): 36–61; Henry Race, "A Historical Sketch of Miss Jane McCrea," *Proceedings of the New Jersey Historical Society,* 2nd ser., 9 (1886/87): 91–102; Margaret Logan Pearsall Smith, "Ann Whitall," *Reperusals and Re-Collections* (1937; reprint, New York, 1968); Samuel Stelle Smith, *A Molly Pitcher Chronology* (New Jersey, 1972); Elizabeth Cady Stanton, Susan B. Anthony and Matilda Joselyn Gage, eds., *History of Woman Suffrage,* vol. 1 (New York, 1881); Frank R. Stockton, *Stories of New Jersey* (New York, 1896); Carolene Taylor, "Women and the Vote in Eighteenth-Century America," *Humanities* 8 (July–August 1978); 16–17; Henry Bischoff Weiss, *Life in Early New Jersey* (Princeton, 1964); Robert V. Wells, *The Population of the British Colonies in America Before 1776: A Survey of Census Data* (Princeton, 1975); Chilton Williamson, *Suffrage from Property to Democracy* (Princeton, 1960); Giles R. Wright, *Afro-Americans in New Jersey: A Short History* (Trenton, 1989).

Chapter Two

Harry E. Barnes, *A History of the Penal, Reformatory and Corrective Institutions of the State of New Jersey* (New York, 1974); Rosalyn Baxandall, et al., eds., *America's Working Women: A Documentary History, 1600 to the Present* (New York, 1976); Rowland Berthoff, "Conventional Mentality: Free Blacks, Women, and Business Cor-

porations as Unequal Persons," *Journal of American History,* 76:3 (1989): 753–84; Robert D. Bole and Lawrence B. Johnson, *The New Jersey High School: A History* (Princeton, 1964); Boyd, *Fundamental Laws;* "Catalogue of the Newark Young Ladies Institute, August 1835," New Jersey Historical Society, Newark, hereafter NJHS; John R. Commons, et al., *History of Labour in the United States,* 4 Vols. (1918; reprint, New York, 1960), Vol. 1; Merle Curti, "Clara Barton," *NAW,* 1:103–08; Mary A. Demarest, "Some Early New Brunswick Schools for Girls," *Proceedings of the New Jersey Historical Society* 53 (1935): 163–85; Silvia Dubois, *Now 116 Years Old: A Biografy of a Slav Who Whipt Her Mistres and Gand Her Fredom,* ed. Cornelius W. Larison (Ringoes, N.J., 1883); Percy Epler, *The Life of Clara Barton* (New York, 1915); Barbara Leslie Epstein, *The Politics of Domesticity: Woman, Evangelism, and Temperance in Nineteenth-Century America* (Middleton, Conn., 1981); Philip S. Foner, *Women and the American Labor Movement: From Colonial Times to the Eve of World War I* (New York, 1979); John T. Foster, *New Jersey and the Rebellion* (Newark, 1868); Cornelia Hancock, *South After Gettysburg: Letters of Cornelia Hancock from the Army of the Potomac, 1863–1865,* ed. H. S. Jaquette (Philadelphia, 1937); Sharon Harley, "Northern Black Family Workers: Jacksonian Era" in *The Afro-American Woman: Struggles and Images,* ed. Sharon Harley and Rosalynn Ferborg-Penn (Port Washington, N.Y., 1978), 5–16; Robert W. Harper, "South Jersey's Angel to Runaway Slaves," *Sunday Press* [Atlantic City], 5 June 1975; Frederick Herrmann, "The Political Origins of the New Jersey State Insane Asylum, 1837–1860," in *Jacksonian Democracy,* ed. Paul A. Stellhorn (Trenton, 1979), 84–101; Susan Hirsch, *Roots of the American Working Class: The Industrialization of Crafts in Newark, 1800–1860* (Philadelphia, 1978); Van Doren Honeyman, "Clara Barton, a New Jersey Teacher," *Proceedings of the New Jersey Historical Society* 5 (1920): 124–25; Henrette S. Jaquette, "Cornelia Hancock," *NAW,* 2: 127–29; Linda Kerber, "Daughters of Columbia: Educating Women for the Republic, 1787–1805," in *The Hofstadter Aegis,* ed. Stanley Elkins and Eric McKitrick (New York, 1974); George Kirchman, "Unsettled Utopias: The North American Phalanx and the Raritan Bay Union," *New Jersey History* 97 (Spring 1979): 25–36; Aileen S. Kraditor, ed., *Up from the Pedestal: Selected Writings in the History of American Feminism* (Chicago, Ill: 1968); Gerda Lerner, "The Lady and the Mill Girl: Changes in the Status of Women in the Age of Jackson," in Lerner, *The Majority Finds Its Past* (New York, 1979), 15–30; Helen E. Marshall, "Dorothea Lynde Dix," *NAW,* 1:486–89, and *Dorothea Dix: The Forgotten Samaritan* (Chapel Hill, 1937); Mary Elizabeth Massey, *Bonnet Brigades* (New York, 1966); Earl Schenck Miers, *New Jersey and the Civil War* (Princeton, 1964); H. P. Powers, "Female Education, An Address on the Anniversary of the Newark Institute for Young Ladies, 21 July 1826," NJHS; George R. Prowell,

History of Camden County, New Jersey (Philadelphia, 1886); William Still, *The Underground Railroad: A Record of Facts, Authentic Narratives, Letters, Etc.* (Philadelphia, 1892); Weiss, *Life in Early New Jersey;* Barbara Welter, "The Cult of True Womanhood: 1820–1860," in *The American Family in Social Perspective,* ed. Michael Gordon (New York, 1973), 224–50; Thomas Woody, *A History of Women's Education in the United States* (New York, 1966); Wright, *Afro-Americans in New Jersey;* Arthur Zilversmit, *The First Emancipation: The Abolition of Slavery in the North* (Chicago, Ill., 1967).

What Women Wore

Nancy Bradfield, *Costume in Detail: Women's Dress 1730–1930* (London, 1968); Peter F. Copeland, *Working Dress in Colonial and Revolutionary America* (Westport, Conn., 1977); C. Willett and Phillis Cunnington, *The History of Underclothes,* rev. ed. (London, 1981); David Freeman Hawke, *Everyday Life in Early America* (New York, 1988); Claudia B. Kidwell and Margaret C. Christman, *Suiting Everyone: The Democratization of Clothing in America* (Washington, D.C., 1974); Jack Larkin, *The Reshaping of Everyday Life, 1790–1840* (New York, 1988); Joan Nunn, *Fashion in Costume, 1200–1980* (New York, 1984); R. Turner Wilcox, *Five Centuries of American Costume* (New York, 1963).

Chapter Three

Susan B. Anthony and Ida Husted Harper, *History of Woman Suffrage, 1885–1900,* Vol. 4 (New York, 1902); Alice Stone Blackwell, *Lucy Stone: Pioneer of Women's Rights* (Boston, 1930); Mary Jo Buhle and Paul Buhle, eds. *The Concise History of Woman Suffrage: Selections from the Classic Work of Stanton, Anthony, Gage, and Harper* (Urbana, Ill., 1979); Carrie Chapman Catt and Nettie Rogers Shuler, *Woman Suffrage and Politics: The Inner Story of the Suffrage Movement* (Seattle, Wash., 1969); J. C. Croly, *The History of the Women's Club Movement in America* (New York, 1898); John T. Cunningham, *New Jersey: America's Main Road* (New York, 1966); Allen Davis, *Spearheads for Reform: The Social Settlements and the Progressive Movement, 1890–1914* (New York, 1967); Delight W. Dodyk, "Winders, Warpers and Girls on the Loom: A Study of Women in the Paterson Silk Industry and Their Participation in the General Strike of 1913." (M.A. thesis, Sarah Lawrence College, 1979) and "Women's Work in the Paterson Silk Mills: A Study in Women's Industrial Experience in the Early Twentieth Century," in *Women in New Jersey History,* ed. Mary R. Murrin (Trenton, 1985), 10–28;

Ellen Carol DuBois, *Feminism and Suffrage: The Emergence of an Independent Women's Movement in America, 1848–1869* (Ithaca, N.Y., 1978); William J. Ellis, *Public Welfare in New Jersey: 1630–1944* (Trenton, 1945); Eleanor Flexner, *Century of Struggle: The Woman's Rights Movement in the United States* (New York, 1975); Foner, *Women and the American Labor Movement;* Amelia R. Fry, "Alice Paul and the Divine Discontent," in *Women in New Jersey History,* 64–80; "Governor Fielder's Vote Is Not for Suffrage," *New York Times* 14 October 1915; J. B. Graw, ed., *The Life of Mrs. S. J. C. Downs: or, Ten Years at the Head of the Women's Christian Temperance Union of New Jersey* (Camden, 1892); Herbert Guttman, "Class, Status, and Community Power in Nineteenth Century American Industrial Cities: Paterson, New Jersey: A Case Study," in Guttman, *Work, Culture, and Society in Industrializing America: Essays in Working-Class and Social History* (New York, 1977), 234–48; Ella Handen, "In Liberty's Shadow: Cornelia Bradford and Whittier House," *New Jersey History* 100:3–4 (Fall/Winter 1982): 49–69; Mary Belle Harris, *I Knew Them in Prison* (New York, 1936); Elinor Rice Hays, *Morning Star: A Biography of Lucy Stone, 1818–1893* (New York, 1961); Frances P. Healy, "A History of Evelyn College for Women, Princeton, New Jersey, 1887–1897." (Ph.D. diss., Ohio State University, 1967); Elizabeth F. Hoxis, "Phebe Ann Coffin Hannaford," *NAW,* 2:126–27; Inez Hayes Irwin, *The Story of Alice Paul and the National Woman's Party* (Fairfax, Va., 1977); James Leiby, *Charity and Correction in New Jersey: A History of State Welfare Institutions* (New Brunswick, 1967) and "Caroline Bayard Stevens Wittpenn," *NAW,* 3:638–39; Roy Lubove, "Cornelia Foster Bradford," *NAW,* 1:218–19; Nancy Oestreich Lurie, "Erminne Adele Platt Smith," *NAW,* 3:312–13; *A History of the New Jersey Federation of Women's Clubs, 1894–1958* (Caldwell, N.J., 1958); Joseph F. Mahoney, "Woman Suffrage and the Urban Masses," *New Jersey History* 87 (1969): 151–72; A. F. R. Martin, *The History of the Newark Female Charitable Society* (Newark, 1903); Men's Anti-Suffrage League, "The Woman Suffrage Crisis in New Jersey," Amelia Berndt Moorfield Papers, NJHS; Rosamond Sawyer Moxon and Mabel Clarke Peabody, *Twenty-five Years: Two Anniversary Sketches of New Jersey College for Women* (New Brunswick, 1943); New Jersey Association Opposed to Woman Suffrage, "Woman Suffrage and the Liquor Question," Amelia Berndt Moorfield Papers, NJHS; Newark Female Charitable Society, *A Century of Benevolence, 1803–1903* (Newark, 1903) and *Newark Female Charitable Society History, 1903–1953* (Newark, 1953); Philip Newman, "The First IWW Invasion of New Jersey," *Proceedings of the New Jersey Historical Society* 58 (1940): 268–83; Mary Gray Peck, *Carrie Chapman Catt: A Biography* (New York, 1944); *Report of the State Board of Education and State Superintendant of Public Instruction, for the School Year Ending August 31, 1870,* n.p., n.d.; George P. Schmidt, *Douglass*

Sources 117

College: A History (New Brunswick, 1968) and "Mabel Smith
Douglass," *NAW*, 1:510–11; Anne Firor Scott and Andrew Scott, *One
Half the People: The Fight for Woman Suffrage* (Urbana, Ill., 1982);
Douglas V. Shaw, "Immigration, Politics, and the Tensions of Urban
Growth: Jersey City, 1850–1880," in *Cities in the Garden State: Essays
in the Urban and Suburban History of New Jersey,* ed. Joel Schwartz
and Daniel Prosser (Dubuque, Iowa, 1977), 35–51; Barbara M.
Solomon, "Antoinette Louisa Brown Blackwell," *NAW*, 1:158–61;
Stanton, Anthony and Gage, *History of Woman Suffrage, 1876–1885;*
Marguerite Dawson Winant, *A Century of Sorosis, 1868–1968* (New
York, 1968); Thomas Woody, *A History of Women's Education in
the United States,* 2 vols. (1929, repr. New York, 1980).

Chapter Four

Karen Anderson, *Wartime Women: Sex Roles, Family Relations, and the
Status of Women During World War II* (Westport, Conn., 1981); Lois
W. Banner, *Women in Modern America: A Brief History,* 2nd. ed.
(San Diego, Calif., 1984); Elizabeth Brody, ed., *New Jersey: Spotlight
on Government* (New Brunswick, 1972); Center for the American
Woman and Politics, "Women in the New Jersey State Legislature,"
Factsheet (New Brunswick, 1984); Citizens' Alliance to Stop E.R.A.
In New Jersey, "So-Called Equal Rights Amendment . . . Do You
Know What It Means?" and "What Is E.R.A.?"; Richard J. Connors,
"The Movement for Constitutional Revision in New Jersey,
1941–1947." (M.A. thesis, Columbia University, 1955); Consumers'
League of New Jersey, *Fiftieth Anniversary Booklet* (Newark, 1950);
Nancy F. Cott, "What's in a Name? The Limits of 'Social Feminism';
or Expanding the Vocabulary of Women's History," *Journal of
American History* 76:3 (1989): 809–29; Cunningham, *New Jersey's
Main Road;* Betty Friedan, *The Feminine Mystique* (New York, 1963;
Felice Dosik Gordon, *After Winning: The Legacy of the New Jersey
Suffragists, 1910–1947* (New Brunswick, 1986); Betty Friedan, *The
Feminine Mystique* (New York, 1983); Linda Greenhouse, "Defeat
of Equal Rights Bills Traced to Women's Votes," *New York Times,*
6 November 1975 and "Foes Aim at Defeat of Federal ERA," *New
York Times,* 9 November 1975; Maureen Honey, *Creating Rosie the
Riveter: Class, Gender, and Propaganda During World War II*
(Amherst, Mass., 1984); Carmela Karnoutsos, "Mary Teresa
Norton," *NAW*, 4:511–12; Stanley Lemons, *The Woman Citizen:
Social Feminism in the 1920s* (Urbana, Ill., 1975); Nancy E. McGlen
and Karen O'Conner, *Women's Rights: The Struggle for Equality in
the 19th & 20th Centuries* (New York, 1983); Gary Mitchell, "Women
Standing for Women: The Early Political Career of Mary T. Norton,"

New Jersey History 96 (Spring/Summer 1978): 27–42; Mary Beth Norton, ed. *Major Problems in American Women's History* (Cambridge, Mass., (1989); William L. O'Neill, *Everyone Was Brave: A History of Feminism in America* (Chicago, Ill., 1969); Annabel Paxton, *Women in Congress* (Richmond, Va., 1945); Barbara Petrick, "Mary Philbrook: The Professional Woman and Equal Rights," in *Women in New Jersey History,* 48–63, and *Mary Philbrook: The Radical Feminist in New Jersey* (Trenton, 1981) and "Right or Privilege? The Admission of Mary Philbrook to the Bar," *New Jersey History* 97 (Summer 1979): 91–104; Warren E. Stickle, III, "The Applejack Campaign of 1919: As 'Wet as the Atlantic Ocean,'" *New Jersey History* 89 (Spring 1971): 5–22; Women's Project of New Jersey, *Past and Promise: Lives of New Jersey Women* (Metuchen, N.J., 1990).

SUGGESTIONS FOR FURTHER READING

Several history texts survey the history of women in the United States. They include *Womanhood in America: From Colonial Times to the Present* (New York, 1975) by Mary Ryan; *The Woman in American History* (California, 1971) by Gerda Lerner; *Woman's Proper Place: A History of Changing Ideals and Practices, 1870 to the Present* (New York, 1978) by Sheila M. Rothman; *The Rise of Public Woman: Woman's Power and Woman's Place in the United States, 1630–1970* (New York, 1992) by Glenna Matthews; *A History of Women in America* (New York, 1978) by Carol Hymowitz and Michaele Weissman; and *Clio's Consciousness Raised: New Perspectives on the History of Women* (New York, 1974) edited by Mary S. Hartman and Lois Banner. Also, *Woman as Force in History* (New York, 1946) by Mary R. Beard stands as a classic in women's history for its claims that American women were a positive factor in the development of the nation.

A valuable bibliography for references, primary and secondary, on women in New Jersey is *New Jersey Women, 1770–1970: A Bibliography* (Cranbury, N.J., 1978) by Elizabeth Steiner-Scott and Elizabeth Pearce Wagle. The references are presented both topically and chronologically, and the text includes an index of names, places and organizations. Primary sources on woman suffrage in New Jersey are included in the Amelia Berndt Moorfield Papers at The New Jersey Historical Society, Newark.

For the study of women during the colonial period, the following standard works are recommended: Elizabeth A. Dexter, *Colonial Women of Affairs* (Boston, 1924); Eugenie Leonard, *The Dear-Bought Heritage* (Philadelphia, 1965); and Mary Beth Norton, *Liberty's Daughters: The Revolutionary Experience of American Women, 1750–1800* (New York, 1980).

For an appraisal of women's situation during the Revolu-

tionary era, see Linda K. Kerber, *Women and the Republic: Intellect and Ideology in Revolutionary America* (Chapel Hill, 1980). Kerber examines the role of women during the war as well as their legal status before and after the war experience. For a similar evaluation, also see Linda Grant DePauw and Conover Hunt, *"Remember the Ladies": Women in America, 1750–1815* (New York, 1976). However, for a negative view of the outcome of the Revolution for women, see Joan Hoff Wilson, "The Illusion of Change: Women and the American Revolution," in *The American Revolution: Explorations in the History of American Radicalism,* edited by Alfred A. Young (De Kalb, Illinois, 1976).

Changes in the roles and status of women during the early nineteenth century are described in the following works: Nancy F. Cott, *The Bonds of Womanhood: "Woman's Sphere" in New England, 1780–1835* (New Haven, 1977) for a positive outlook on the experience of middle-class New England women; see Barbara Welter, "The Cult of True Womanhood, 1820–1860," *American Quarterly* 18 (1966): 151–174, for a negative perspective on women's spheres, as well as that of Gerda Lerner, "The Lady and the Mill Girl," *American Studies* 10: 1 (Spring 1969): 5–15. *A New History of Women's Education in the United States,* 2 vols. (New York, 1929) remains the standard study of the education of women in the new nation.

For an overview of working women in the United States, see Barbara Mayer Wertheimer, *We Were There: The Story of Working Women in America* (New York, 1977), which stresses the poor quality of working conditions for women; and Alice Kessler-Harris, *Out to Work: A History of Wage-Earning Women in the United States* (New York, 1982), noted for its analysis of labor history with societal factors.

Background for women's involvement in social reform and the early years of feminism during the nineteenth century may be found in the following: Barbara J. Berg, *Remembered Gate: Origins of American Feminism: The Woman and the City, 1800–1860* (New York, 1974); Ellen Carol DuBois, *Feminism and Suffrage: The Emergence of an Independent Women's Movement in America, 1848–1869* (Ithaca, N.Y., 1978); Catherine Clinton, *The Other Civil War: Women in the Nineteenth Century* (New York, 1984); Mary P. Ryan, *Women in Public: Between Banners and Ballots, 1825–1880* (Baltimore, 1990); and Lori

Ginzberg, *Women and the Work of Benovolence: Morality, Politics and Class Consciousness in Nineteenth-Century United States* (New Haven, 1990).

References for the Progressive Era, during which women became actively involved in social reform and the suffrage movement, are numerous. Of special note are the following: William O'Neill, *Everyone Was Brave: The Rise and Fall of Feminism in America* (Chicago, 1969) (O'Neill coined the term "social feminist" to describe the women's movement during this time); Lois Banner, *Women in Modern America: A Brief History* (New York, 1974); Banner, *Elizabeth Cady Stanton: A Radical for Woman's Rights* (Boston, 1980); Aileen Kraditor, *Ideas of the Woman Suffrage Movement, 1890–1920* (New York, 1965); Neale McGoldrick and Margaret Crocco, *Reclaiming Lost Ground: The Struggle for Woman Suffrage in New Jersey* (Summit, 1994); Robert E. Riegel, *American Feminist* (Lawrence, Kansas, 1968); Allen F. Davis, *Spearheads for Reform: The Social Settlement and the Progressive Movement, 1890–1914* (New York, 1967); Jill Conway, "Women Reformers and American Culture, 1870–1930," *Journal of Social History* 5 (Winter 1971–72): 164–177; Karen J. Blair, *The Clubwoman As Feminist: True Womanhood Redefined, 1868–1917* (New York, 1980); and Ruth Bordin, *Women and Temperance: The Quest for Power and Liberty, 1873–1900* (Philadelphia, 1981). Specialized studies on working women and the nature of women's work during the era are Robert W. Smuts, *Women and Work in America* (New York, 1959); Helen L. Sumner, *History of Women in Industry in the United States* (New York, 1971, 1911); and Theresa Wolfson, *The Woman Worker and the Trade Unions* (New York, 1926.

The best general discussion of the status of American women after the suffrage campaign is *The American Woman: Her Changing Social, Economic, and Political Role, 1920–1970* (New York, 1972) by William H. Chafe. See also Chafe's *The Paradox of Change: American Women in the 20th Century* (New York, 1991). For women in the twentieth century, also see Anne Firor Scott, *Making the Invisible Woman Visible* (Urbana, Illinois, 1984) and Felice Gordon, *After Winning: The Legacy of New Jersey Suffragists, 1920–1947* (New Brunswick, 1986). For women in politics in New Jersey, see Richard P. and Katheryne C. McCormick, *Equality Deferred: Women Candidates for the New*

Jersey Assembly, 1920–1993 (New Brunswick, 1994). For the impact of the Depression and the New Deal on women, see the following: Caroline Bird, *The Invisible Scar: The Great Depression and What It Did to American Life, from Then Until Now* (New York, 1966); Lois Scharf, *To Work and to Wed: Female Employment, Feminism, and the Great Depression* (Westport, Conn., 1980); and Susan Ware, *Beyond Suffrage: Women and the New Deal* (Cambridge, Mass., 1981).

For a discussion of the impact of World War II on the lives of women, see Maureen Honey, *Creating Rosie the Riveter: Class Gender and Propaganda during World War II* (Amherst, Mass., 1971) and Karen Tucker Anderson, *Wartime Women: Sex Roles, Family Relations and the Status of Women during World War II* (Westport, Conn., 1981). For a brief discussion of the status of women in the postwar era, see Sheila Tobias and Lisa Anderson, "What Really Happened to Rosie the Riveter," *MSS Modular Publications,* Module 9, 1974.

The best-known critique of the social role of the housewife of the 1950s and the beginning of contemporary feminism is Betty Friedan, *The Feminine Mystique* (New York, 1963). For background and analyses of the contemporary women's movement, see the following: Barbara Sinclair Deckard, *The Women's Movement: Political, Socioeconomic, and Psychological Issues* (New York, 1975); Sara Evans, *Personal Politics: The Roots of Women's Liberation in the Civil Rights Movement and the New Left* (New York, 1979); Jo Freeman, *The Politics of Women's Liberation* (New York, 1975); Carl N. Degler, *At Odds: Women and the Family in America from the Revolution to the Present* (New York, 1980) and Glenna Matthews, *"Just a Housewife": The Rise and Fall of Domesticity in America* (New York, 1987).